To Eli and Heather

Acknowledgments

I'd like to thank Cathleen Small for the superior editing job on yet another one of my books. My gratitude also goes to Todd Larson, who got me started in photography in the first place. His patience and collaboration on many photo shoots makes photography worth its while. I'd also like to thank my agent, Carole McClendon of the Waterside Agency, as a person who I can always depend on to help me put my work out there in the best possible light, as well as for helping me develop the idea for this book and the entire series to come. Finally, I'd like to thank Ramiro Ortega and family, Suellen Evavold, and Robert Stone for helping me put together the portraits in the book.

About the Author

Matthew Bamberg is a photographer and writer based in Palm Springs, California. He began his career in the arts as a graduate student at San Francisco State University in 1992. His work in the visual and media arts included video production and software applications. He completed his M.A. in Creative Arts in 1997. After being a public-school teacher for 14 years, Bamberg became a photographer and writer. He began to photograph for the articles he was writing while working for the *Desert Sun* and *Palm Springs Life* magazine.

Bamberg has traveled all over the world, photographing everything from wildlife to architecture. His photography has been published in many magazines, both locally and in Asia. This book is the first of a series of books that covers the ins and outs of not only creating winning photos, but also putting them out in the world, both online and on the ground. Part of his collection of photos is published in this, the first book of the *Quick and Easy* series, *101 Quick and Easy Secrets to Create Winning Photographs.*

Bamberg is also the author of *Digital Art Photography for Dummies* (Wiley, 2005) and *The 50 Greatest Photo Opportunities in San Francisco* (Course Technology PTR, 2009), as well as coauthor of *David Busch's Pentax K200D Guide to Digital SLR Photography* (Course Technology PTR, 2009).

Contents

CHAPTER 8
Breathing Life into People ...119

CHAPTER 9
Making Animal Photos Sharp and Fun137

CHAPTER 10
Spicing Up Photos with Lens Flare, Noise, and Other
Unusual Effects ..149

Chapter 11
Composing with Landscapes163

Chapter 12
Shaping Up with Symmetry.............................177

Chapter 13
Technical Tango...189

Chapter 14
Daytime, Nighttime, Anytime................................201

CHAPTER 15
Back to the Future

Introduction

In this book, the secrets to creating winning photographs vary from composition to technical techniques and from creative to artistic applications that use both in-camera and post-processing methods. You'll find that with this book, you'll be able to produce almost any kind of photograph that you can imagine.

A winning photo can consist of a lot of things. What constitutes a winning photo for one person may not be the same for another. The first step to achieve that "wow" photograph is to go with your gut in terms of subject matter. Then, follow some of the winners in this book to learn about all of the processes and techniques that go into taking a compelling photograph.

Winning a prize in a photography contest is one way to get ahead of the pack of millions of photographers who want their pictures to receive recognition. There are hundreds of photography contests you can enter, from the annual *Smithsonian Magazine* contest to the photography contests hosted by Canon and Nikon. (For many of the latest contests, go to photocompete.com.)

But it's not always winning a prize that makes a winning photo. It can be simply a picture that you feel is a winner, one that you can frame and hang in your home for all your friends to see. It can also be one that is published in either a photo magazine or a book. Once you have a good collection of winning photos, pick up my next book, *101 Quick and Easy Secrets for Using Your Photos*, and use it as a guide for putting your work out in the world.

Around-the-World Photography

This book not only gives specific instructions for creating winning photos, but it also is a collection of travel photos, the likes of which you've never seen before.

As an avid traveler who has hit astounding nooks and crannies in the world, I'll show you a world that you might not have known existed. From the skyscrapers of modern China to remote Asian villages where oxen still sow the fields, and from the odd and offbeat Paris to stunning Caribbean beaches, the photos are filled with narrative and, hopefully, will have you studying all the elements that they contain. You'll find yourself involved with each photo as each demonstrates a technique that you can take with you the next time you're out in the field.

The photos in this book were taken over a 10-year period beginning in 1999. Most are digital, but a few were scanned from 35mm negative film. I took the photos on a series of more than a dozen trips during that time period. As you'll see in the coming chapters, the 101 photo ops contain additional related ideas in sidebars, most of which contain some commentary on the trip itself. The sidebar information is meant to give additional instructions for taking similar shots as well as to provide a slice-of-life background on some of the places I visited.

Cameras and Lenses

While I'm out shooting or giving photography seminars, many people ask me about my photography equipment. I use a wide range of professional and semi-professional equipment. Some of it I'd recommend to people, and some of it I'd advise against purchasing. I use two cameras: a Canon EOS 5D and a Canon Digital Rebel X. I usually have a Canon 24-105mm f/4L IS lens on the 5D and a Tamron f/3.5-f/6.3 28-300mm on the Rebel XT. When I want wider angles, I opt for my Sigma 17-35mm f/2.8-f/4 lens. I can recommend Steves-digicams.com and dpreview.com for finding reviews about cameras and lenses. Flash and flash units aren't covered in this edition because ambient light is the only light necessary to take the photos in this book.

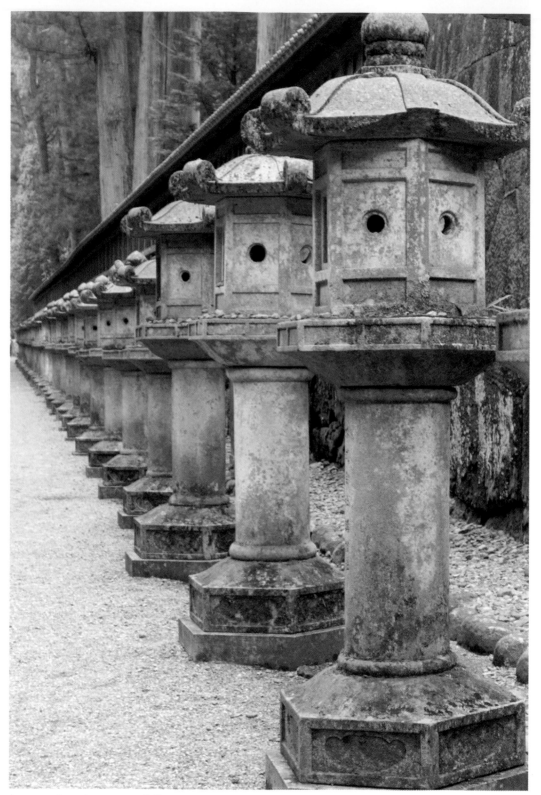

Japanese temple ornamentation.

Making Your Photographs Look 3D

If you unlock a door to open it to other dimensions, you can look beyond the two-dimensional space to travel into another world of not only a third dimension, but also of other dimensions. Sound a bit Twilight Zone-ish to you? If so, it's because some of the words I've used are from the intro to the '60s show *The Twilight Zone*. When I photograph, I look forward to delving into the third, fourth, and fifth dimensions, picturing a world that I like to think of as the Twilight Zone—one of deep perspectives, enhanced space, and creative mystery.

Adding Depth to Your Photos Using Perspective

Supplemental Elements: aperture, repeating objects, color, exposure compensation
Location of Picture: Quito, Ecuador
Camera Settings: f/10, 1/250 sec, ISO 200, 28mm

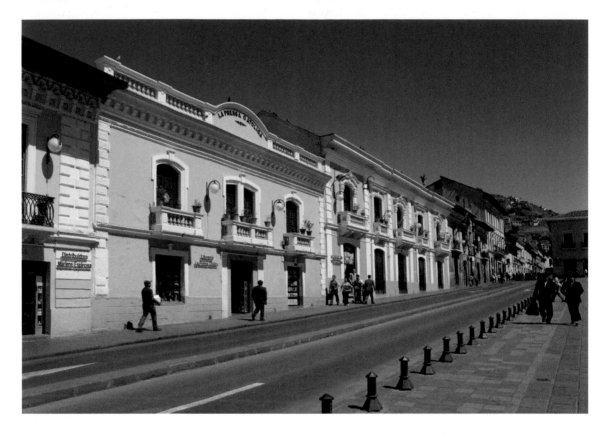

There's nothing like a street that seems to glide into the frame. In this shot of a street in Quito, Ecuador, there are several things you can look for to get this great perspective effect. In the picture, you've got the row of buildings going to a point seemingly to infinity (see "The Vanishing Point" sidebar), the road (without any vehicles), the median strip, and road guards running in the same direction, all to the same vanishing point. The sidewalk runs in the same direction also, but it is stopped from continuing by a building behind the pedestrians. If the building weren't there, the sidewalk, too, would go to the same vanishing point. Also note that the road guards get smaller as you move into the distance, as do the people. Finally, when I took the shot, I positioned my camera as close as I could to the line in the road (see the foreground of the image) and the guard posts to increase the drama of the perspective.

Adding to the perception of increased depth are the contrasting colors—the peach of the Colonial buildings and the deep blue of the sky, along with the neutral colors of the road and sidewalk. In the distance is what some people would call a *payoff*—a green hill that slopes down behind the building with a curve. Because it was such a sunny day, I shot with my exposure compensation down a few stops to enhance the color. You can also do this quite easily after the fact if you shoot in Raw format. (For more about Camera Raw, see the "Using Camera Raw to Do It All" sidebar in Chapter 6, "Creating Mood Shots Using Weather.") I could have shot at normal exposure and lowered the exposure in Raw format during post-processing. (You can increase and decrease exposure by using sliders in the Raw Menu window of image processing programs.) This would have the same effect as lowering the exposure compensation out in the field.

THE VANISHING POINT

Let's take a look at one of the most important graphic arts concepts there is—vanishing points. If you go out onto a street and look as far as you can see, you'll see that the parallel lines that make up its sides and the line in the middle (if there is one) look as if they'll eventually meet at a point in the distance. That imaginary point is called a *vanishing point*, and it is said to exist an infinite distance away from your line of vision.

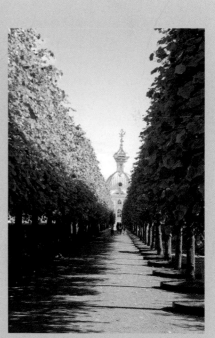

Try putting a point on a piece of paper about one-third up from the bottom of the page, then draw lines from different points on the bottom to the point at the top. You can imagine the lines to be sides of roads. Now, if you drew vertical lines from one of the lines that goes to the vanishing point and made them smaller as you moved toward your vanishing point, you can imagine these vertical lines to be repeating objects, such as the trees leading to the Russian palace in the perspective shot. The trees in this shot are called the *framing element*.

Perspective photo of trees leading to a Russian palace.

Perspective has to do with the way three-dimensional objects are perceived in a two-dimensional frame. The vanishing point in this image of trees leading to a Russian palace (the framing element) is the point at which the lines made by the treetops and path eventually would have met if they hadn't run into the palace in the background. You can add more focus to the depth of your photos by creating an imaginary point to which all lines meet. When you use one vanishing point, you can get your viewers' eyes to glide from the foreground to the background of your photo in one glance. Notice, too, in this shot how the various shadows move toward the vanishing point—an extra special effect that could make this a winning photograph.

Finding Different Angles to Enhance Perspective

Supplemental Elements: ISO speed, indoor photography, noise
Location of Picture: Imperial dining room at Peterhof, near St. Petersburg, Russia
Camera Settings: f/11, 1/20 sec, ISO 800, 32mm

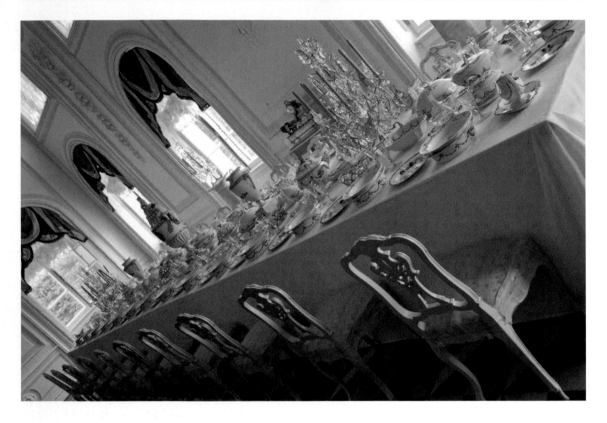

When I saw this imperial dining room at Peterhof, my first inclination was to turn my camera so I could get the entire dining room table in the frame. Not only did it fit, but the angle enhanced the look of the photo, and it really lets the viewer know the size and scope of the room. I set my ISO speed to 800—any higher and the noise, or graininess in the picture, would have been overwhelming. Because you can't use a tripod or flash in a palace (see the "Photographing in Museums and Palaces" sidebar), all you have to work with to keep your picture clear are ISO speeds and a body that doesn't shake much. I wanted the entire table to be sharp, so I took a risk and set my aperture to a fairly narrow opening. It was risky because I was shooting in aperture priority mode, and when you set a narrow aperture, the camera makes up for the loss of light by keeping the shutter open longer for a proper exposure. The longer the shutter stays open, the more chance there is for subject blur. I got a sharp photo, so the risk was worth it.

PHOTOGRAPHING IN MUSEUMS AND PALACES

Probably the first thing you want to do when you get a new camera is learn how to turn off the flash. It's also the first thing you want to know before you step foot in a museum with your camera. If a museum lets you take pictures, most of the time they will not permit the use of a flash.

The symbol for a flash on most cameras is a lightning bolt. Turning off the flash on most point-and-shoot models requires merely navigating to a lightning bolt with a line through it and selecting the setting. On dSLR models with a built-in flash unit, all you have to do is take pictures in the manual modes, and the flash won't pop up unless you press the button for it to do so. The button is usually on the body of the camera near the pop-up flash unit.

The next thing you want to know how to do with your camera before you shoot in a museum or palace is change the ISO speed. The ISO speed is a determination of the sensor's light sensitivity. The higher the number, the more sensitive the sensor is to light, and the better your chance for a clearer picture. There's one drawback, though, if the number's too high: noise. Noise in a photo is the tiny colored dots that spread out in certain areas of the image.

Strasbourg Museum of Modern and Contemporary Art in Strasbourg, France.

On most point-and-shoot and dSLR cameras, you can find the ISO setting by navigating through the menu on the LCD screen. I always try to use ISO 800 indoors when there is some natural light coming though. In most cases there's much less chance of getting noise at 800 ISO than at 1000 ISO. If you're trying to take a picture in a poorly lit room, getting it clear and without noise gets to be more of a challenge unless you have a tripod. Using ISO speeds greater than 1000 doesn't yield great results, especially if you want to blow up your image or submit it for stock photography use. When all is said and done, your selection of ISO speeds is going to be dependent on your camera model. Some of the new Nikon and Canon dSLR models shoot very well at high ISO speeds.

Finally, when you use a flash, natural colors from ambient light turn flat. This image of the Strasbourg Museum of Modern and Contemporary Art shows the kind of color you can get when you keep your flash off.

Using Multiple Objects to Create Depth

Supplemental Elements: perspective, street photography
Location of Picture: Montreal, Quebec, Canada
Camera Settings: f/5.6, 1/250 sec, ISO 100, 55mm

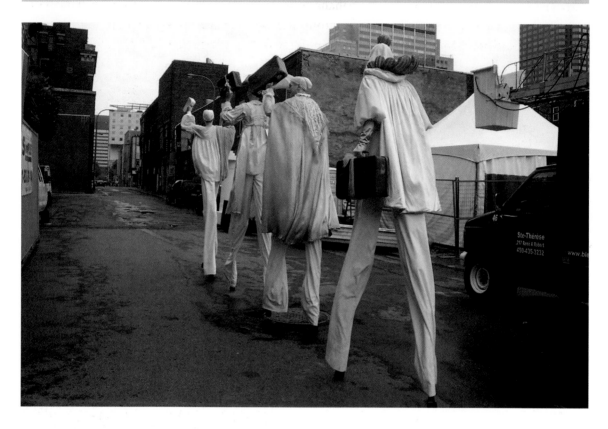

In this shot, a group of characters on stilts are walking, flipping their suitcases back and forth. The figures decrease in size as you move from the foreground to the middle ground. It's an interesting perspective to photograph a line of people in this way, especially if the people happen to be walking on stilts.

I wasn't expecting to pass this bunch of people, but I had my point-and-shoot camera just in case if I did stumble across a candid photo op. I had set my camera to auto mode so if something came up quickly, I could snap it. In the picture the first three men have their vintage suitcases up in the air, and the last one is carrying it by his side, a configuration that sets a tone of

movement and comedy. The entire situation is odd: a group of men walking down an empty alley, looking as if they're nearly as tall as the buildings.

Another fortunate aspect of this photo is that the alley is spotlessly clean. The camera calculated the settings adequately; the men are all sharp. Later, I found out that these guys were coming from the Just for Laughs Festival (www.hahaha.com), which I attended in the following days of my trip. I was fortunate to catch them as a group without any other people around. The Just for Laughs Festival is the largest comedy festival in the world. It takes place in July in Montreal.

Building in the South of France.

Obtaining Good Bokeh (Blur)

Supplemental Elements: f-stop, aperture priority mode
Location of Picture: Inle Lake, Myanmar
Camera Settings: f/6.3, 1/500 sec, ISO 400, 420mm

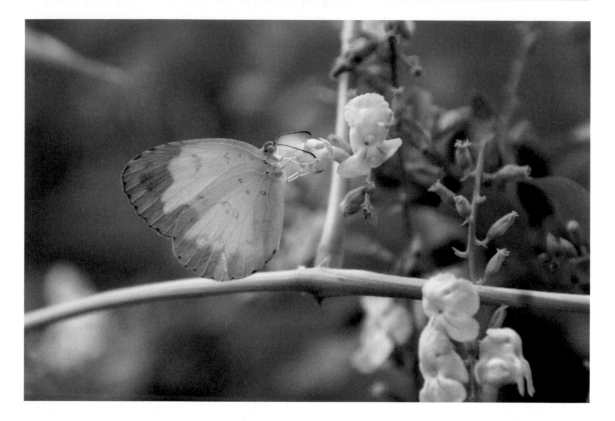

Everyone likes a good macro shot, but not everyone has a good macro lens. Fortunately, you can get almost as good of results by using a telephoto lens at its largest focal length. The pros don't consider this macro—they call it close-up photography, but who cares what they call it as long as you get a crystal-clear picture of interesting subject matter and, yes, great background blur?

In this shot taken with a Digital Rebel XT with a Sigma 28-300mm lens, the depth of field was large enough to keep the butterfly and the flower on sharp. When I shoot with a macro or telephoto lens, I generally find the point where my subject is in focus by moving my lens in and out in an effort to get it in focus at the closest point to the object. The bokeh will vary according to the focal length you are shooting at, how close you are to the subject/object, how wide your aperture (see the "Using Aperture Priority Mode and Depth of Field" sidebar) is open, and the quality of the lens with which you are shooting.

Sometimes you'll think your entire subject is in focus, when in fact it is not—perhaps it's blurred around the outer edges. If this is the case, you can adjust your aperture so more of the subject/object is in focus.

Nature provided me with great contrasting colors among the yellow butterfly, the lavender and yellow flowers, and the green stems and leaves. Also, my lens was good enough to create a soft and silky background blur. Note, also, that point-and-shoot cameras with macro mode do a very good job of magnifying subjects, and you can get some pretty good shots with these cameras.

Whether you're shooting with a macro lens or a telephoto lens, using a tripod helps to control camera shake, though a tripod won't do any good if it's windy and the flowers or insects you are photographing are blowing around.

USING APERTURE PRIORITY MODE AND DEPTH OF FIELD

If you look at the dial on most dSLR cameras, you'll probably find an Av or an A printed on it. (Canon usually uses Av, whereas Nikon uses just A.) The A stands for *Aperture* mode, and the Av stands for *Aperture Value*. Both are commonly referred to as *aperture priority* mode.

Aperture values are also called *f/stops*. When your camera is in Av (or A) mode, it determines the shutter speed according to what aperture you've chosen to give you the best exposure.

If you have a camera that lets you shoot manually (meaning it has a manual mode, a shutter priority mode, and an aperture priority mode), then you can fine-tune just how much of your image is sharp. First, you set your camera to aperture priority mode. Then you set an aperture value. Values (or

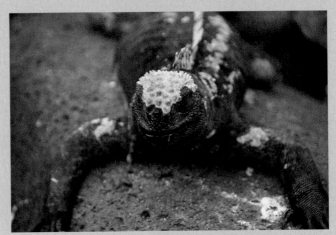

Picture of Galapagos lizard with narrow depth of field.

f/stops) run in incremental steps starting from f/1.4 and ending at f/64; the lowest values correspond to the widest aperture openings, making less in your frame sharp, and the highest values correspond to the narrowest openings, making more in the frame sharp. (Sharpness depends on other factors as well, but for the purposes of this section, we'll just stick to the aperture effect.) How much of the frame is sharp is called the *depth of field*. As you can see in this shot of a Galapagos lizard, the depth of field is narrow, as only the lizard's face is sharp.

Choosing Interesting Foregrounds

Supplemental Elements: aperture, repeating objects, color, exposure compensation
Location of Picture: Antigua, Guatemala
Camera Settings: f/5, 1/125 sec, ISO 200, 140mm

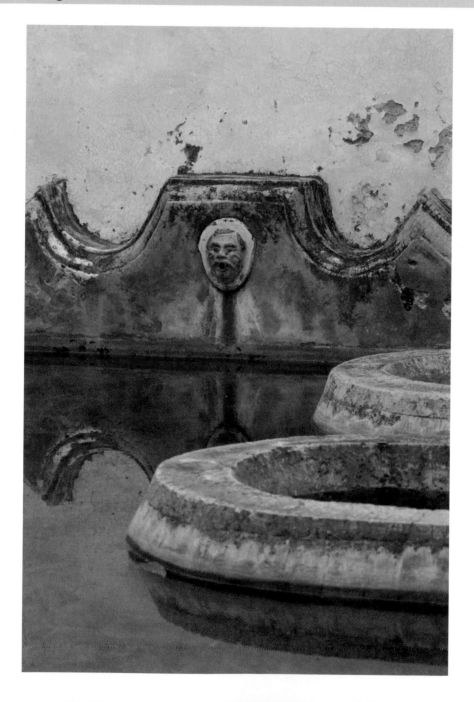

When you think about it, a flat surface has no dimension, and what you want in your shots is a feeling that you could walk right into the photo instead of being just a viewer of a photograph. To get that walk-right-in feeling, add an interesting foreground. In this image of a fountain in Guatemala, two semicircular shapes have been included in the frame. These shapes offer an introduction to the main subject of the photograph—the sculpted waterspout.

If you look closely, the waterspout and the surrounding wall remain sharp, while the foreground objects are soft. Some professional photographers avoid foreground blur; however, I think it moves the viewer's eyes into the picture in this case.

There's another major factor in this picture—the fountain isn't working. This circumstance played to my advantage in that the partial reflection of the back wall's shapes is astonishingly vivid, something that wouldn't have happened if there were water coming out of the spout and falling into the fountain. The fact that the water isn't terribly clean also is an advantage because it causes the water's surface to look as if it is metallic.

Finally, notice the muted colors of the surfaces, which were caused by both the elements and the water reacting with the concrete. The patina has made the colors so unusual that you'd have a difficult time naming them.

Farm animals in Myanmar.

Using Curves to Fill Your Frame

Supplemental Elements: perspective, focus lock, landscape photography, color, lines
Location of Picture: Dover, U.K.
Camera Settings: f/4, 1/2000 sec, ISO 200, 85mm

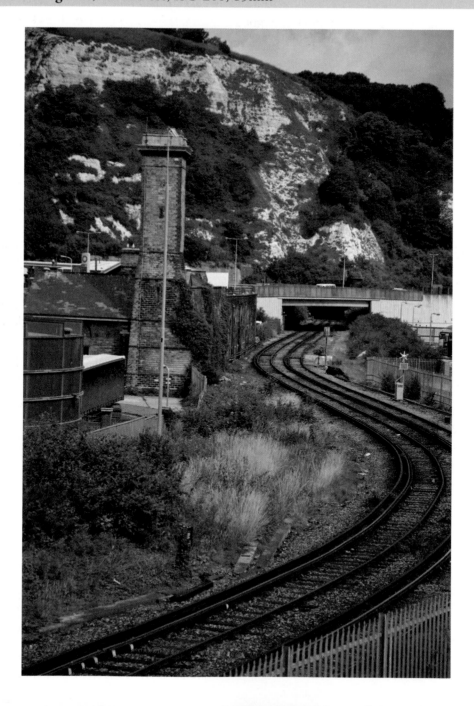

While walking away from the port of Dover, England, I came across this winding railroad track, which I immediately recognized as an ideal photo op because of the curves that it could bring to my frame. I focused on the bottom of the building in this Dover, U.K., shot by pressing my shutter release halfway down, then I moved my camera while keeping the shutter release halfway down so that the building was located one-third from the right side of the frame. (See the "Focus Lock: A Great Framing Aid" sidebar.) I got a pretty good depth of field for using such a wide aperture, due to the fact that the light was good and my focal length wasn't too big (I didn't zoom in or out that much). Ordinarily, if you want a landscape clear from foreground to infinity, you should use a tripod and shoot at apertures smaller than f/9 or f/10. In this picture, however, I was only concerned with keeping the middle ground in focus so that the track was vivid in the frame compared to the background. Last but not least is the white area of the mountain. If you look closely, it begins where the train track ends and then curves around to the far-left corner of the frame.

FOCUS LOCK: A GREAT FRAMING AID

The focus lock feature of cameras lets you recompose your shots so that you can follow photography rules, such as the Rule of Thirds. On a point-and-shoot, where the autofocus point is in the middle of the viewfinder, and if you've set the focus point on your dSLR to the middle of the viewfinder (because on these cameras you can set your focus points at several places in the viewfinder), you can focus on an object in the middle of the frame. To recompose your shot, lock your focus by pressing the shutter release button halfway down. Move your camera from side to side to find the framing you like and take your picture with the subject/object still in focus.

Note that you can only move your camera in a plane even with your subject or object. If you move forward or backward, or if your subject does, you'll lose focus. In this image of an abandoned house, I set my focus point on the ripped-up cushion of the second chair, and at that point it was in the middle of the viewfinder. Next, I pressed my shutter release button halfway down, moved my camera to the framing you see in the figure (moved the autofocus point to just below the window) so that the chair's placement followed the Rule of Thirds, and took the picture.

The focus point for this abandoned house was set just below the window.

I always have my focus point set so it focuses in the middle of the viewfinder. Then, on every shot, I can use the focus lock quickly without having to fumble around with my camera to change the focus point placement. So where is this abandoned home with a cast of baby blue on the wood planks that cross the picture, adding a bit of peace to a wrecked environment (because horizontal lines add calmness to a photo)? It's in Kelso, between Palm Springs, California, and Las Vegas, Nevada.

Looking in through a Window or Door

Supplemental Elements: color, narrative, light
Location of Picture: Santa Monica, California
Camera Settings: f/5.6, 1/400 sec, ISO 100, 260mm

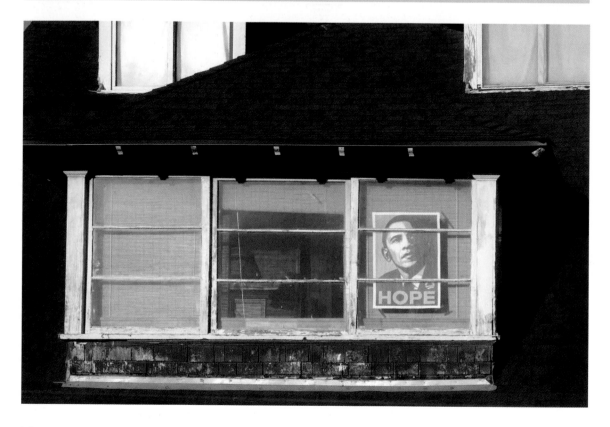

There are many ways to catch views looking inside a building through doors, windows, and other building openings. One way is through the glass of a window, which, if well lit, can provide an area of depth to your photograph. Sometimes all you need is a small area of depth for dimension. The biggest issue in getting a good photograph through a door or window is having the right light.

This image of a set of windows on a Santa Monica house wouldn't have worked if the face of the building wasn't exposed to the sun. The area through the middle window would have been dark, flattening the image. Also working for additional dimension in this photo is the top-left window, which is behind the gable of the roof.

More powerful than dimension in this photo is the symbolism. The HOPE poster sits behind glass and horizontal lines from the window's framing. Generally, horizontal lines indicate calm-

ness and vertical lines indicate strength. So, in addition to the windows providing dimension, they also communicate three things: hope, calmness, and strength—quite a powerful message. For more about messages and photography, see the "Narrative: Photography's Fifth Dimension" sidebar.

NARRATIVE: PHOTOGRAPHY'S FIFTH DIMENSION

In science and math, you can have 3D vectors, which inhabit space and can be oriented in any direction in space using x, y, and z axes. If you add movement, you create the fourth dimension—time. I like to look at photography as having not only an additional time element in 3D space, but also the element of narrative, which you could think of as a fifth dimension of reason and thought.

There are many ways you can get a photograph to communicate to your viewers. The mere act of giving viewers a peek through a window or doorway introduces a bit of voyeurism to a narrative. By using lines, shapes, forms, and symmetry, photographers can create a wide variety of feelings and movements.

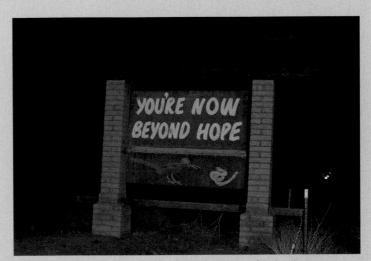

A flash was used at night to catch this picture of a sign just past Hope, Arizona.

Images and color can also be used to address human emotions. Think about how war is depicted, and you'll come up with the color of red. Blues, on the other hand, might signify peace. Colors are also temperature-driven. Reds are warm to hot; blues are cool to cold.

Text, too, communicates a message—one that's more direct. In this image of a painted roadside sign, the text communicates a flippancy of language. You can see the text clearly because the picture was taken at night with a flash at a shutter speed of 1/60 second and an aperture of f/4.

Narrative is what makes photography exciting. When I saw the "Beyond Hope" sign, I reacted quickly after first thinking a moment and then "getting" the message. I turned my car around, got out, and snapped a close-up of the sign using my flash. Just in case if you didn't catch the flippancy, Hope was a town I had just passed. The phrase "beyond hope" has another meaning, too—and it's not complimentary!

Including a Large Area of the Ground in the Frame

Supplemental Elements: Leading lines
Location of Picture: Downtown Warnemunde, Germany
Camera Settings: f/8, 1/500 sec, ISO 200, 24mm

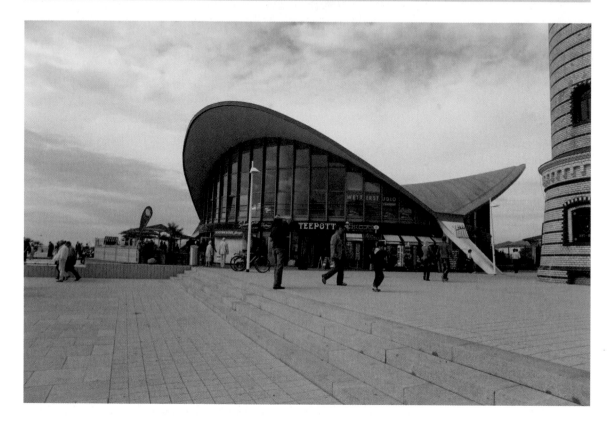

In this shot in Warnemunde, Germany, I devoted the bottom third of the photograph—the foreground—to the ground. The ground and stairs in the photograph draw the eye toward the main subject—the Googie building. (See the "Googie Architecture" sidebar.) Note that the stairs produce diagonal lines that not only slice the foreground in half, but also lead the viewer's eyes to the main subject—the Googie building. Leading lines are lines in your image that lead the viewer from the bottom of the scene to the object of interest. In this shot I used a narrow enough aperture to get everything in the image sharp.

GOOGIE ARCHITECTURE

In the United States, the mid-20th century was a time when the car was king. In an effort to lure motorists off the road, businesses had to come up with creative, attention-getting architecture. Architects created buildings with erratic curves and swooping slopes in the roof, as well as floor-to-ceiling glass all around. Some of the buildings looked as if space aliens could be living in them. The style came to be referred to as *Googie architecture*. The name *Googie* comes from the name of a mid-century modern-style coffee shop in Los Angeles that architect John Lautner designed. Googie architecture is found around the perimeters of downtown areas in many cities around the world. This image shows a mid-20th century building in Palm Springs, California, with a roof that swoops into the sky.

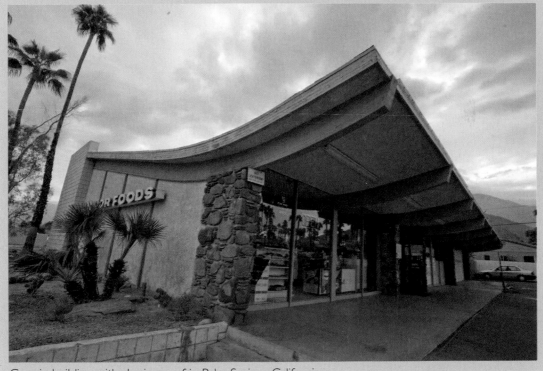

Googie building with sloping roof in Palm Springs, California.

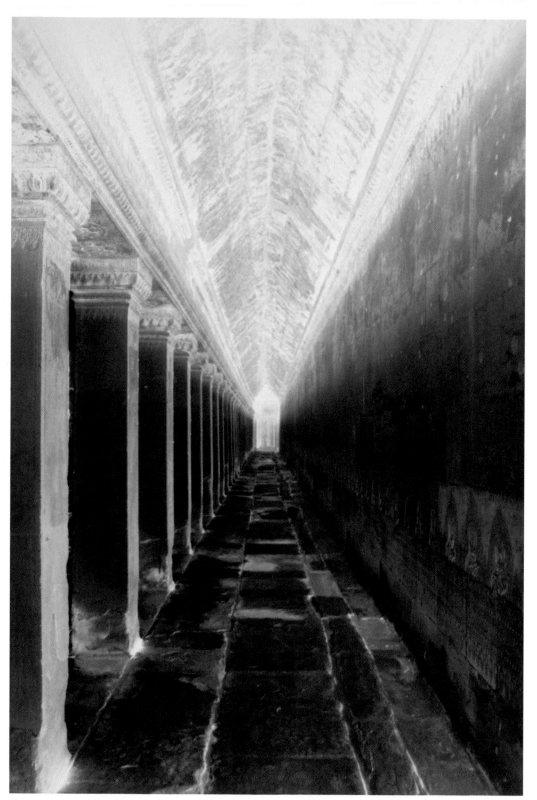

Open doorways let light into ruins.

CHAPTER 2
Painting with Light

Light can peek out of little holes or flood vast plains. It can be dim or bright, dappled or streaked. One thing is for sure, though—it will change in an instant. A photographer is ever aware of the light as he shoots. Painting your frame with light can involve a quick shot taken at just the right moment or a shot where you must play the waiting game. Everything you frame in an image is light dependent. One thing you'll have to remember when you're out shooting: Don't expect your camera to take in the light in a predictable fashion. At best, it's a trial-and-error process—one in which you get better based on the time you spend shooting.

Finding Available Light for a Clear Picture Indoors

Supplemental Elements: tripod, ISO speed, autofocus point, depth of field, self-timer
Location of Picture: Desert Hot Springs, California
Camera Settings: f/8, 0.6 sec, ISO 100, 28mm

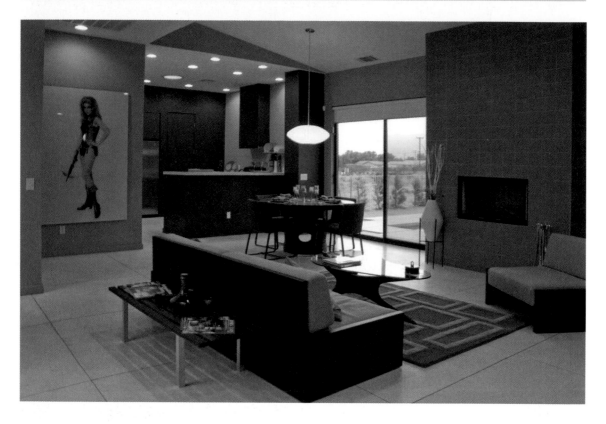

I've found that natural lighting works great for indoor photographs if you have a tripod. You can catch any room in your home in a sharp photo, provided you have some lights on or the blinds or curtains open. Set your camera to aperture priority mode with an aperture of about f/8. You'll get good depth of field at this aperture. Also, turn your self-timer on so that the camera will wait a few seconds before it shoots. This will eliminate any blur from camera shake when you press the shutter release button. If you don't have a tripod, you can increase your ISO speed to get a sharp shot. The drawback there is that you increase your chance of getting noise.

In this image of a model home, I shot without a flash and using a tripod. There is a general rule that I broke when taking this picture: You shouldn't mix different types of light in a shot.

For example, if you shoot indoors, either have all the shades closed and use the house lighting or open the blinds and use only the sunlight. I could have closed the blinds to have only the indoor lighting in the picture. I broke the rule because I like the effect of the sunlight, including its reflection off of the designer coffee table.

These days, breaking the rule isn't a big deal. Those rules were made for film. It used to be that when you mixed light, the color balance of your shot would be off. Today, with Photoshop and Raw files, it's easy to fix any color balance problems you have in post-production (when you get your image to the computer).

I also really like having all the light fixtures on while having the blinds open so you can see the outside landscape. The fact that the blinds are open makes the room look less claustrophobic.

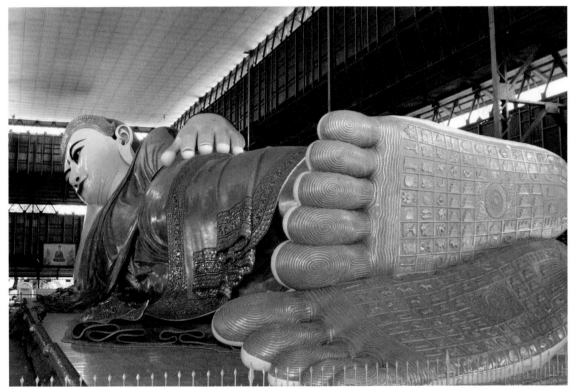

Buddha in Myanmar.

Using Reflected Light to Enhance Subjects

Supplemental Elements: wind, polarizing lens
Location of Picture: Jurong Bird Park, Singapore
Camera Settings: f/6.3, 1/1000 sec, ISO 400, 60mm

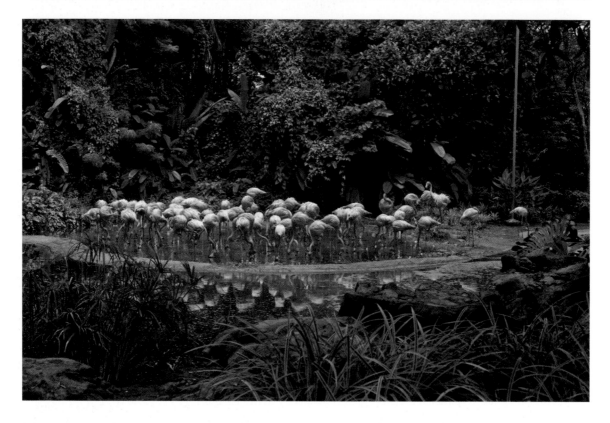

The Jurong Bird Park in Singapore offers a multitude of photo ops, and no photo op is better than the flamingo display near the front entrance to the park. This image shows that the number of birds in the exhibit and their close proximity to each other creates an elliptical area of pink in the frame. The birds' reflection by the still water beneath them expands their presence in the frame, doubling the amount of pink you see. There's also great contrast between the color of the birds and the vegetation that surrounds them. The best photographs of reflections come on windless days when the water is calm.

THE PUNISHING WIND

Windless days are ideal for getting extra-sharp pictures, especially landscapes, because wind can cause movement blur in lush settings. With trade winds howling in the Caribbean, the palm fronds sway. For photographers, that spells movement blur for landscape images that include lots of vegetation. This picture was taken at the top of a hill in Barbados. I kept movement blur of the foliage in the image to a minimum despite brisk winds by taking off my polarizing filter. When your camera is in aperture priority mode, that filter causes the shutter speed to slow down so that the lens will pick up more of the sway of the palms and other trees, which ends up as blurred leaves in the frame. If the wind is high enough, even without the filter there is blur, no matter how fast the shutter opens and closes. In this image, I also reduced the blur's impact by following the Rule of Thirds, but instead of allowing two-thirds of the frame for land and one-third for sky, I did the opposite and framed my image with two-thirds sky and one-third land. In doing so, I not only lessened the blur's impact, but I also picked up that beautiful tropical sky.

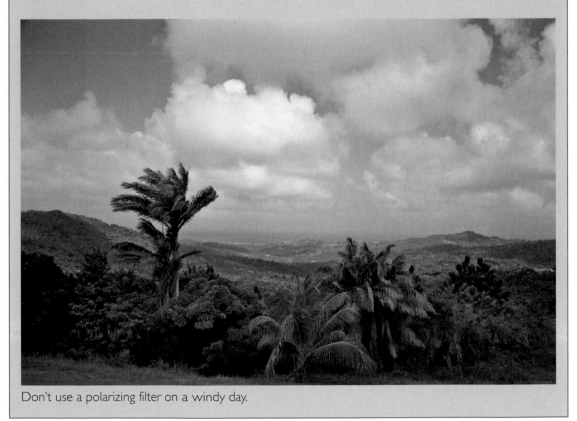

Don't use a polarizing filter on a windy day.

Using Fill Flash

Supplemental Elements: flash
Location of Picture: Palm Springs, California
Camera Settings with Flash: f/5.6, 1/160 sec, ISO 100, 92mm
Without Flash: f/8, 1/200 sec, ISO 100, 92mm

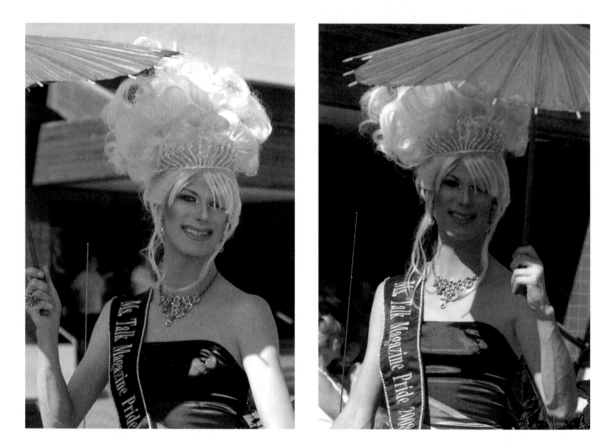

If you're at a parade and are able to buck the crowd for a close-up picture of one of the partici-pants, you might consider using a flash, especially if that person is wearing a hat or holding an umbrella. So, just what will a flash do? When a subject's head and body have a shadow cast over him or her from a hat or umbrella, the shadow can appear harsh in the frame, as shown in the image where the participant is holding his umbrella in his left hand. To soften and lighten it a bit, you can use fill flash, or flash used to create more even light over subjects that have shadows cast over them. In the picture where the subject is holding his umbrella in his right hand, a pic-ture taken with flash, you see much more subtle shadow over the participant at a gay parade. The fill flash did the job it was supposed to do.

You don't have to set your camera to take fill flash. All you have to do on some dSLR cameras with internal flash units is turn on the flash unit by opening it using the button for the flash release on the body of the camera. The camera will automatically adjust how much light will come from the flash according to the ambient light around you.

SKIP THE FLASH

Some people think that the flash should be used indoors no matter what. As a matter of fact, there are many people who let the camera decide when they should use flash, and the camera will sometimes activate the flash in shade outdoors, even when there is plenty of light for a sharp image. This isn't always the best way to get a great image. It is, however, one of the best ways to get a sharp image. Whenever you decide not to use the flash by shutting it off when you are photographing indoors, you risk getting soft subjects in your frame. Of course, the more ambient light you have indoors, the better chance your image will come out sharp. Say, for instance, you are photographing a subject right by a window or in an open hallway—there will be plenty of light to make your image sharp. Whenever you have enough sunlight indoors to light up a subject, I personally think it just looks better and more natural. This picture shows a man typing (the old-fashioned way) in a photograph taken with all natural light. In this image the subject was not by a window, but inside a building entryway. A flash would have taken away from the old-fashioned look of the photo—which, by the way, was taken in Myanmar.

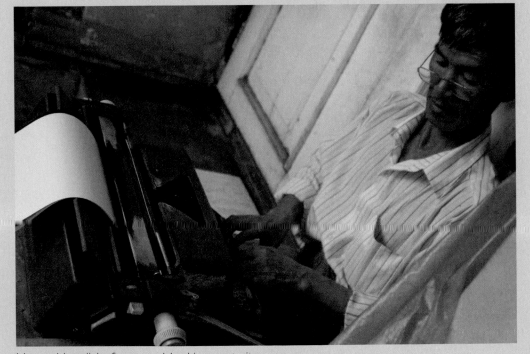

Use ambient light for natural-looking portraits.

Taking Advantage of Light Streaming through Windows, Doors, or Other Building Openings

Supplemental Elements: autofocus, depth of field
Location of Picture: Palm Springs, California
Camera Settings: f/5.6, 1/200 sec, ISO 800, 80mm

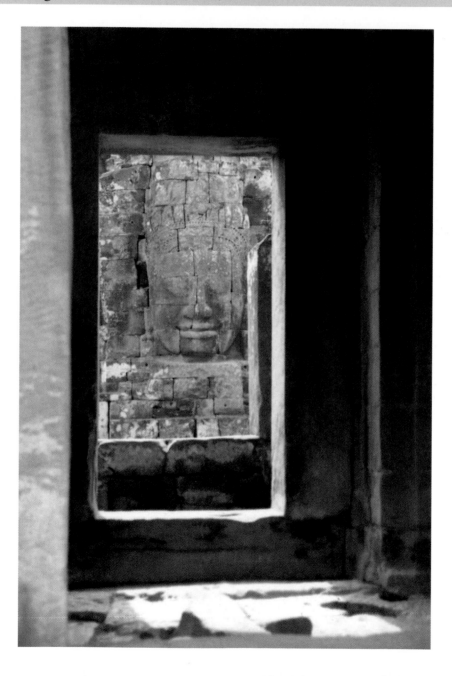

The buildings of Angkor Wat have elaborate, impressive plans, each one with its own symbolism and geometrical patterns. Much of the art at Angkor Wat has to do with good versus evil. Peek through many of the entryways, and you'll see not only light sweeping through, but also views of sculptural elements like that shown in this image. Note that the autofocus point was set on the sculpture with the aperture open fairly wide, so you have a narrow depth of field with the sculptural art sharp and the walls inside the entryways soft.

WHEN AUTOFOCUS WORKS PERFECTLY

Capturing a good picture of wildlife roaming free at a Yosemite National Park can be challenging. The light can be iffy, the background cluttered. The deer at this national park offered an ideal photo op. The animals were not scared of people and even seemingly posed for a shot. It wasn't an accident that I got to photograph mother and offspring in an open area with the offspring's head leaning lovingly under the mother's. I had to wait around for them to get to the clearing after they walked for a while. I also was prepared as I was hiking along a forested trail.

I had my camera set to its widest aperture in aperture priority mode so that I knew it would choose a fast enough shutter speed to increase the possibility of getting a sharp picture. I also was at the right place at the right time, which, although many professional photographers won't admit it, is half of what's needed for a good picture.

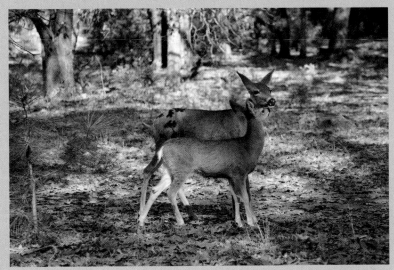

The dappled light helps to create a compelling setting for this picture of deer.

What makes this picture just a bit better than a snapshot of a wild animal? I got an almost perfect depth of field—that is, the area of sharpness covers just the deer without extending into the background—in part because I had my autofocus point set on the baby's head. Also helping me get a good depth of field was that the focal length of the lens was 92mm (fairly long focal length) and the aperture had been set to f/4 (fairly wide aperture), giving just the softness I needed for the background. And, last, the dappled light adds a nice touch to the ambient environment.

Making Silhouettes by Shooting into the Sun

Supplemental Elements: autofocus point, light meter, center-weighted metering
Location of Picture: Bagan, Myanmar
Camera Settings: f/8, 1/800 sec, ISO 200, 30mm

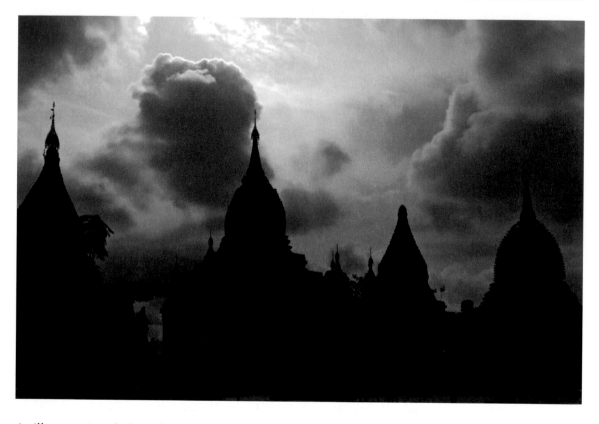

A silhouette is a dark outline of a subject or object placed in front of a light background. It can be shot by placing your subject or object between your lens and the sun. In other words, you're shooting into the sun when it is low on the horizon. While I generally don't recommend that you shoot directly into the sun because there is a small possibility that it could harm your sensor, you can shoot around it. In this image, I shot the row of temples in Bagan, Myanmar, so that the sun is just above where the shot was framed. You can see the light emanating from the top of the frame. The buildings, which are some 1,500 years old, come up as silhouettes because they were backlit from the sun behind them.

To ensure that the buildings are dark and the sky is detailed, set your autofocus point (which also sets the exposure point) somewhere on the lighted background—one of the clouds in the sky, for instance. If you set your autofocus point on one of the buildings (a dark area of the frame), you'll likely overexpose your sky at the expense of properly exposing the buildings. Finally, make sure your camera's light meter is set to anything other than a matrix setting that will average the bright and dark areas.. On many cameras, a good setting is center-weighted average metering.

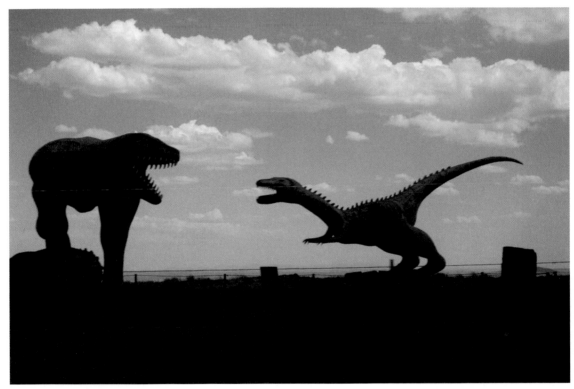

California highway ornaments.

Backlighting a Tree, Plant, or Leaf Using the Sun's Light

Supplemental Elements: Rule of Thirds, backlight
Location of Picture: Singapore
Camera Settings: f/9, 1/125 sec, ISO 100, 30mm

To be sure, Bangkok is a congested city where pollution from the traffic mixes with the hot, humid air to make one feel rather uncomfortable. However, the city is filled with vignettes of tropical flowering plants, and I happened to catch one during a walk around the city. You wouldn't think that noontime in the tropics, when the sun is high overhead, would be an optimal time to take a picture of a plant. Normally it wouldn't be, because of harsh shadows that the petals and leaves cast over one another. But in this picture, I shot from under the huge flowers and an elephant ear leaf so that they look translucent. What's unusual about this shot is that you see most of the sun's light through the flowers' petals and the elephant ear leaf. I also followed the Rule of Thirds, with the bright pink shapes one-third from the right side of the frame. Also notable is the contrast between the dark-green palm fronds in the background and the flowering plant in the foreground.

Sunflower in Inle Lake, Myanmar.

Making Flowers Look Painted by Photographing Them in Low Light

Supplemental Elements: ISO speed, white balance
Location of Picture: San Francisco, California
Camera Settings: f/4, 1/50 sec, ISO 1000, 100mm

If you want soft light and a subtle contrast between subject and background in an indoor flower photograph, turn up your ISO and shoot with a steady hand (or tripod). You can find flower arrangements indoors at churches, weddings, funerals, and florists. This image shows the painting-like quality when you take a close-up picture of flowers indoors without a flash at high ISO speeds. The frame took on the hue of the ambient lighting surrounding the subject. Since the room was lit with fluorescent lights, the hue tends to be the color of the lights, which are white. For more about measuring ambient lighting, see the sidebar "White Balance as Art." The white light causes the flowers' colors to mute with the petals taking on pastel hues.

WHITE BALANCE AS ART

White balance has to do with the color temperature of ambient light. The color temperature measures the kind of light coming from a source. Artificial lighting sources (light from light bulbs) have low color temperatures, and outdoor natural lighting sources (light from the sun on a clear day or light from the sun on a cloudy day) have high color temperatures. Pictures taken when the ambient light is at low color temperatures can tend to have red, yellow, or orange casts, and pictures taken at high color temperatures tend to have blue casts. Most of the time setting your camera to auto white balance

An image that has a blue cast when the white balance was set to fluorescent light on a sunny day.

will do the trick for getting proper color casts in your photo. If you are a pro or an advanced amateur, you may want to take a reading from a gray card under the lighting at the scene and adjust the white balance using the controls in your camera's menu.

The white balance settings on cameras shift the color of the light so that you get natural color casts in your photo. If it doesn't shift correctly, there are a variety of white balance options on most cameras to which you can change after viewing your image on the LCD screen. They are usually listed in order from lower color temperature light sources to higher ones (Tungsten, Fluorescent, Daylight, Cloudy).

To get special effects, you can set your white balance to a setting different than what the ambient light conditions are. For example, you can set your white balance to, say, fluorescent to shoot on a sunny winter day for a subtle bluer cast to your photo, as shown in the image in this sidebar. It's also very easy to adjust white balance in post-processing (manipulation of images after you've shot them) if you shoot in Raw format. In many image processing programs, there is a Raw dialog box that has a slider where you can adjust the white balance to any temperature you want. In other words, you can warm up your picture with yellows and oranges by raising your color temperature or cool it down by lowering your color temperature on the spot.

Fabric factory, Myanmar.

CHAPTER 3
Adding Action to Your Frame

There are all kinds of ways to create action in your frame. You can introduce motion blur to show people moving, you can freeze the action, like in a sports shot, or you can pan to get background blur. When you introduce motion blur, the name of the game is to have everything in the frame sharp except for the subject or object that is moving. To freeze subjects you have to shoot in good light with fast shutter speeds. To get a subject or an object sharp with a blurred background, you have to pan. After you read this chapter, you'll have the keys to getting a wide variety of action shots using these methods.

Panning a Shot to Blur Background

Supplemental Elements: shutter priority mode, autofocus point
Location of Picture: Palm Springs, California
Camera Settings: f/4, 1/6 sec, ISO 400, 28mm

Panning, the process of moving your camera while the shutter is open, can be a tricky proposition. You're bound to get effects that you didn't intend to, many of them being wild and beautiful. One of the goals of panning is to get a sharp subject within a blurred background, giving the illusion of movement in the subject.

The first thing you have to remember when using this technique is that the subject you are panning is not likely to come out absolutely sharp, especially if you don't use a tripod. What you're looking for is the illusion of it being sharp relative to the movement (blur) in the background. These two nighttime images show the different effects you can get from panning. If your subject is severely blurred with the background after you pan, you probably want to take the shot while panning again several times until you get the subject relatively sharp. Sometimes, though, you'll get a terrific, unusual blurred shot (see "The Panning Miracle" sidebar) without the subject being sharp.

Finally, don't forget to turn off any image stabilization settings if you have them on your camera or lens. If you leave them on, you'll have less of a chance of getting the subject sharp.

THE PANNING MIRACLE

Into panning with your camera like they do in the movies? Well, here goes: To blur the background, set your camera on a tripod with the lens pointing at a point where the subjects will pass (or point your camera at the passing subject if you don't have a tripod). Choose a setting that will not employ the flash in low light. (Shutter priority mode is good.) If

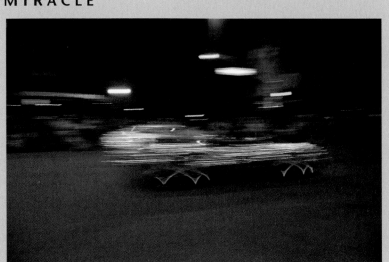

Sometimes the subject needn't be sharp in a panning shot.

you're shooting during the day, find a low light situation (some shade) and manually set the shutter speed on your camera to 1/20 to 1/30 second in shutter priority mode—the mode that lets you set the shutter speed while your camera sets the f-stop. When you see the subject get close enough, set your focus point on it by pressing your shutter halfway down. Then, press your shutter all the way down and follow the subject, trying to move your camera along with the subject. All this happens quickly, so you'll have to move your camera quickly and then repeat it over and over again as the subject passes by.

Creating Blur to Show Movement

Supplemental Elements: ISO speed, program mode
Location of Picture: Nga Phe Monastery, Inle Lake, Myanmar
Camera Settings: f/8, 1/30 sec, ISO 800, 75mm

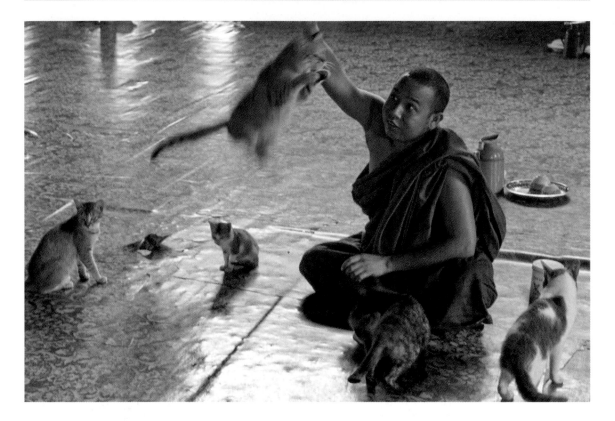

Word of mouth tells of the Jumping Cats Monastery in Myanmar. It's an attraction in this South Asian country not to be missed. The temple is situated in a building that sits on stilts on the edge of Inle Lake. The cats line up to jump through a hoop, after which they get a treat for the trick.

Inside the temple natural light from the windows seeps through, but overall the space is poorly lit. I found that a good picture could be had by setting my ISO speed to 800, large enough to eliminate blur, yet small enough to avoid noise. I didn't have a tripod to take the picture, but I had a technique that helped me to get a sharp shot. I sat down and placed my elbows on my knees to brace myself while I held the camera to take a shot. The technique worked well enough—additional insurance (in addition to a high ISO speed) for a sharp shot of the man while the jumping cat was blurred, which shows action in the frame.

Normally you can expect a sharp handheld shot when the shutter speed is less than the inverse of the focal length (1/75 for this shot). In this shot I stretched the rule a bit so that I got a sharp shot at 1/30 second (my camera didn't shake much when I took the shot), which is a bit slower than the rule's 1/75 second calculation. You can shoot images like this where you're inside and something's moving by setting your camera to aperture priority mode and shooting at about f/8 and then at f/5.6 and f/4, or by setting your camera to shutter priority mode and shooting at 1/80 second and then at 1/30 second. You could also use program mode, which is discussed in the "Program Mode Options" sidebar.

PROGRAM MODE OPTIONS

While you can always use aperture priority and shutter priority modes, there's another option—program mode. In program mode, you can change settings to equivalents that produce the same exposure, but using different f-stops and shutter speeds at the turn of a dial.

You'll notice that when the program mode changes your settings, those with more narrow apertures increase the depth of field.

During early evening something else also happens when you shoot with a narrow aperture—light from lamps and other sources is dispersed in all directions, making lights look like stars. The effect is kind of like when you squint your eyes (corresponding to a narrow aperture) and see light

Narrow apertures cause the light from street lamps to look like stars.

dispersing outward from its source. This picture shows the docks in San Juan, Puerto Rico, in early evening. The image was taken with an aperture of f/22. The narrow aperture caused the lights in the pictures to look like stars.

Finding Subjects in Action on the Street

Supplemental Elements: composition, auto mode, aperture priority mode
Location of Picture: Cathedral City, California
Camera Settings: f/11, 1/1250 sec, ISO 800, 40mm

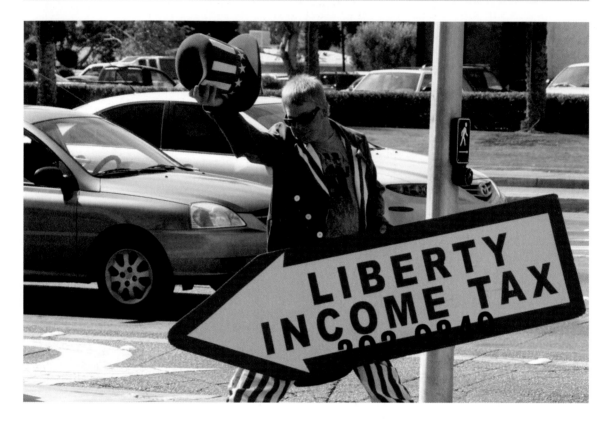

If you look hard in most cities and towns, you can find someone doing something interesting on the street. One of my favorites is the human sign. This picture shows one saluting his audience (people in their cars) by taking off his hat. I saw him while driving in the Coachella Valley of California. Since I usually carry a camera with me in the car, I was able to jump out and take his picture. Before I did, I asked him, and he cooperated by posing with his take-off-the-hat gesture of showmanship.

In going through my picture files, I have found that there are great photo ops on the street from time to time. They range from jugglers, to acrobats and dancers, to musicians—each performer doing his own thing in the moment. To get pictures of people in action on the street, carry your camera with you whenever you can and take the time to stop and take pictures of street performers in action as soon as possible after you see them. You can set your camera to auto mode

before you start off, or you can choose to shoot in aperture priority mode with a wide aperture to freeze the action or more narrow apertures to blur the moving parts of the body. Program mode is also an option with this kind of shot. It lets you rapidly choose an f-stop or shutter speed depending on conditions.

DON'T FORGET THE SPECTATORS

Sometimes the best part of an action shot of street performers isn't the performers themselves, but the audience watching. This image shows spectators around a singer and dancer performing in a park in Shanghai, China. The man and woman in wheelchairs in the foreground and the rest of the spectators on the left side of the frame make the area where the singer and dancer are performing look more like a stage. I had to frame the image from the perspective of what the people in wheelchairs were watching to get the theatrical aspect of the event. In doing so, I've caught the essence of a sweet community scene that is common in Chinese culture. If I had just photographed the dancer or the dancer and singer together, the image wouldn't have been nearly as effective because you wouldn't have gotten a sense that this performance is a small community event.

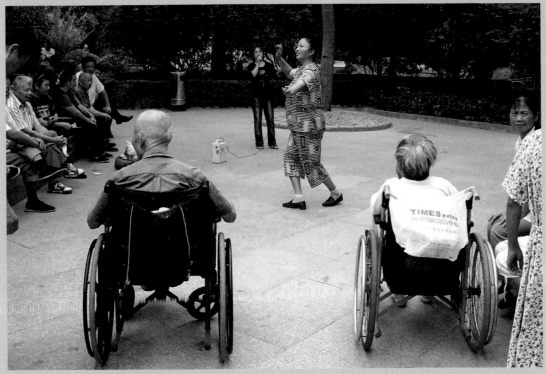

Adding spectators to the frame can enhance your photo's narrative.

Finding Acts of Affection

Supplemental Elements: burst mode
Location of Picture: Jurong Bird Park, Singapore
Camera Settings: f/6.3, 1/125 sec, ISO 400, 400mm

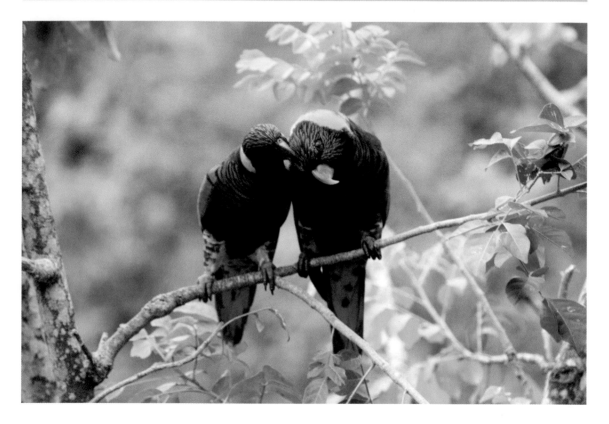

The positioning of the pair of birds in this image suggests that they like each other. With the forest of the aviary in the background and with their heads turned just so, this photo op is one of hundreds that can be had at the Jurong Bird Park in Singapore. The park has more than 9,000 birds from 600 species. The shot was one of about a dozen I took when the camera was set to burst mode. The two pictures taken in sequence after this one are shown in the "Burst Mode Tells a Story" sidebar.

The action of showing affection can be caught in a variety of poses. Consider these:

❋ Two people lying together on the ground with an arm around each other, taken from above

❋ Two people looking at each other with a bouquet of flowers on their lap

✳ A face peeking from behind a pet sitting on a bed

✳ A baby's feet in between a parent's feet

✳ A woman sitting on bench with a man lying down with his head on her lap

✳ An embrace in the ocean

✳ A man kissing a dog's nose

✳ Man standing facing lens with arms crossed, woman with side to lens, holding his arm— or vice versa.

✳ A man lifting up a woman (or vice versa)

✳ A woman embracing a child in the foreground from behind

BURST MODE TELLS A STORY

The drive/burst mode on most dSLR cameras offers three options: single image capture, burst, and self-timer. Single image capture is for normal picture-taking, burst mode is for when you want one picture taken after another, and the self-timer mode is for when you want the camera to count down before taking a shot. What's nice about burst mode is that you can tell a story of an event that takes place over a second in time. These two images show that the birds' closeness was only momentary. Many cameras set to burst mode will take one picture after another every 0.33 seconds. That's a rate of three frames per second. Many camera models can shoot more photos in a second, too. It sounds fast, but when you consider that many video cameras record at 30 frames per second, you'll realize that a dSLR camera's burst mode is relatively slow.

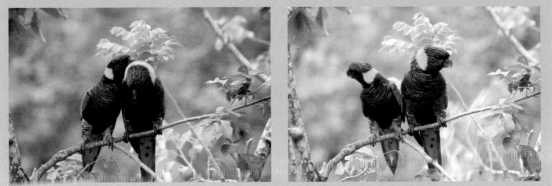

Burst mode lets you take a series of pictures that can tell a story.

Using Close-Ups to Isolate Action

Supplemental Elements: aperture priority mode, depth of field
Location of Picture: Yangon, Myanmar
Camera Settings: f/5.6, 1/60 sec, ISO 800, 124mm

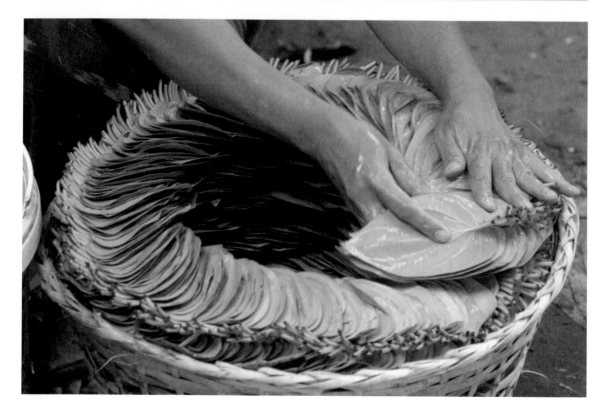

There are three important points you can learn from the image here. The first all-encompassing factor is the circular shape of the basket, which totally fills the frame. Filling a frame with an object is one of the main ways to ensure a good photograph. It provides the viewer with focus. If I had shot the surrounding environment—a busy marketplace—the focus of the leaf-filled circular basket would have been lost.

The second incredible feature of the photograph is the layout of the leaves inside the basket. What a time-consuming task the vendor has gone through to make her product look palatable! Other than choosing my camera settings and framing the shot, all the work has been done for me in terms of getting a wow-factor photograph.

The third feature of the image is the hands, neatly framed in right third of the frame. But that's not all that the hands, which arrange the leaves, offer. They are wet, which gives the right part of the photo a slippery look, an interesting texture that keeps viewers glued to the action at hand.

BRING HOME PIZZA FROM ITALY

Whether it's pastries from Paris or pizzas from Rome, saving them for a lifetime without having them spoil is one of the gifts photography gives us. This picture shows different kinds of pizza as seen through a shop window in Rome. The pizzas are cut in front of customers as soon as they come out of the oven. I was able to catch the cutting in action, and every time I look at this photo, the sumptuous taste of the Italian delight comes back as a delightful flashback from my trip to Rome a few years ago.

There's plenty of light from above, so I obtained a sharp shot, with the exception of the hand cutting the pizza with a knife. It is blurred, which effectively shows how rigorous a cut is being made to get through the dense crust of the pie. All in all, a fast cut of a beautiful pizza with a sharp knife is action that is well-focused and will have viewers' taste buds tingling. To catch this or any other close-up items, use a wide aperture in aperture priority mode. That will ensure that at least part of the pizza will likely be sharp—at wide apertures, shutter speeds are fast enough to prevent softness.

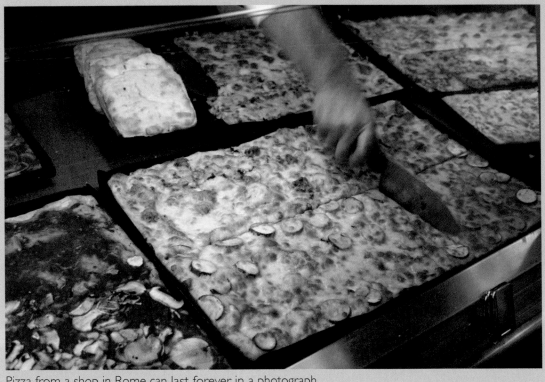

Pizza from a shop in Rome can last forever in a photograph.

Adding Ripples/Splashes to Bodies of Water

Supplemental Elements: aperture, depth of field
Location of Picture: Myanmar
Camera Settings: f/8, 1/640 sec, ISO 400, 36mm

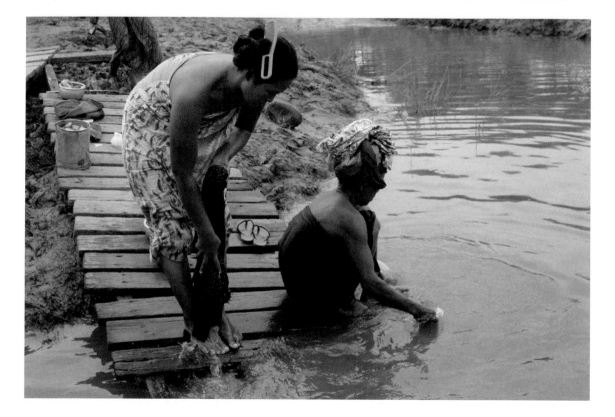

There's nothing like photographing an object in the water. Whether it is solitary ripples on a pond after a pebble has been thrown in or a diver making waves (if he's a good diver, just ripples) as he hits the water, ripples and splashes will sell your viewers with excitement.

This image shows women washing clothes in a lake. The clothes-washing is sending ripples all the way to shore. Also interesting are the splashes of water caused by the woman pulling a garment out of the water. There were three important things I needed to do to get a sharp image with a good depth of field. The first, the weather, was very cooperative, an overcast day in the tropics—bright light without ugly shadows. The second was my aperture setting, which was neither wide nor narrow, but open just enough to get good depth of field—a sharp photo from where the woman were washing the clothes all the way to the shore. Last, was the shutter speed.

I shot in aperture priority mode so that the camera calculated the shutter speed. Since the shot was outdoors and there was plenty of light, the shutter speed was quite fast, also helping to keep the subjects and background sharp. When the light is bright, I can shoot with a low ISO, ensuring a shot that is clear of noise (those tiny colorful dots that can fill the frame if you shoot at very high ISO speeds).

DIFFERENT-SIZE SENSORS, DIFFERENT FOCAL LENGTHS

If you've ever seen a frame of film negative (it's hard to believe that fewer and fewer people use film these days!), you know that it's shaped like a rectangle. To be exact, it's a rectangle that measures 24x36mm. Many digital cameras carry sensors of that size, but they are the more expensive cameras. Some less expensive models come with smaller sensors.

Suppose you take a picture with a 50mm lens using a camera with a full-frame sensor, and you take another one with the same lens attached to a camera with a smaller sensor. The camera with the smaller sensor will give you an image that is cropped off. To get an equivalent view, you need to use a wider focal length (smaller focal length number) with the camera that has the smaller sensor.

For some cameras you have to multiply by a factor of 1.5 to get a full-frame equivalent. For example, if you shoot with the smaller-sensor camera at 35mm, that would be like using the full-frame sensor camera at 50mm. Shoot at 70mm on the smaller-sensor camera, and it would be like shooting at 100mm on the full-frame-sensor camera. The 1.5 is called a *1.5 crop factor*.

Galapagos shoreline.

Old building in Columbia, California.

Adding or Subtracting with Shadows

Shadow plays a vital role in your shots. It can enhance an image, from giving it more dimension to having it communicate additional feeling. But shadows can disrupt an image, too. They can get in the way of what otherwise would have been a gorgeous shot. Just as lighting can change from moment to moment, so can shadows. They can disappear when the sun goes behind a cloud, only to come back dark and unruly. Creating a compelling image with shadows takes time and experience, but once you know the tricks, it's easy to tame shadows so they work well in your photography.

Keeping Your Own Shadow out of the Frame

Supplemental Elements: zoom, focal length
Location of Picture: San Juan, Puerto Rico
Camera Settings: f/5, 1/500 sec, ISO 200, 35mm

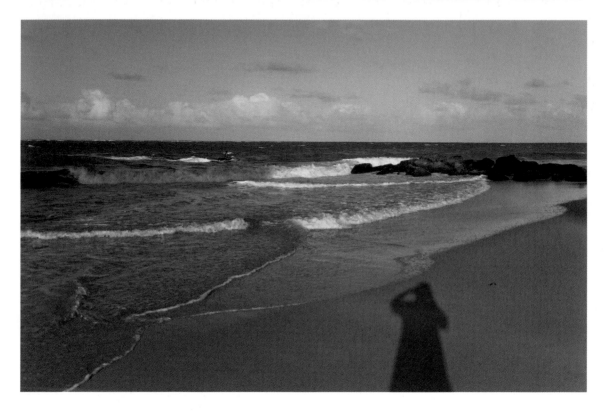

If you're shooting a landscape with your back to the sun in the late afternoon, there's a good possibility that your shadow is going to end up in the frame. Sometimes you won't notice that your shadow is in the way until you see the picture enlarged on your computer. This is especially true if the landscape has vegetation in the foreground of your shot. The dark green of plants makes the shadow hard to see on an LCD screen, but you'll definitely find it there when you go home and download the image to your computer. This beach landscape shows my shadow in the frame. To eliminate the shadow, I could have repositioned myself without my shadow cast in the frame, which would give me a landscape from a different angle than the one shown here. Your own shadow isn't the only kind of shadow that can be cast in the frame. For more about other shadows cast in the frame, see the "Wait or Zoom Options for Eliminating Shadows" sidebar.

WAIT OR ZOOM OPTIONS FOR ELIMINATING SHADOWS

Sometimes there are more options to eliminate shadows than just moving to another spot or waiting for a different time of day to take the shot. In the first of these two images, a shadow of a ship has been cast in the foreground of the frame. Since the shot was taken on a partly cloudy day, I could have waited until the sun went behind a cloud, and the shadow would have disappeared. The other alternative that I had when I was on the ship was to zoom in over the shadow, as shown in the second image. In this case, zooming in and reframing the shot worked because there was still plenty of shadow-free foreground space to get a good image.

The shadow of a ship is cast in the frame. You can zoom in to eliminate the ship's shadow.

Mixing Shadows and Sun in the Frame

Supplemental Elements: autofocus points
Location of Picture: Bangkok, Thailand
Camera Settings: f/6.3, 1/200 sec, ISO 100, 90mm

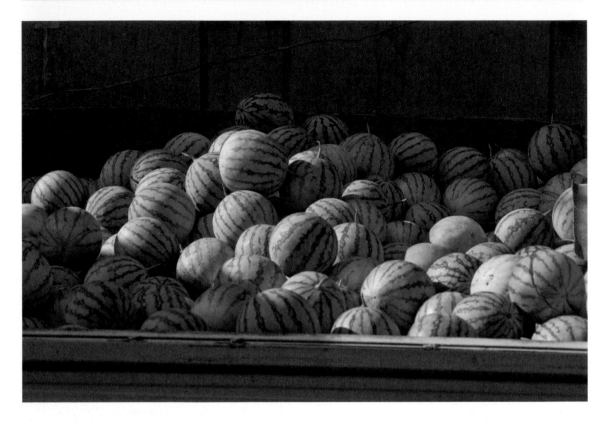

There are times when you don't want to mix shadows and sunlight—times like those discussed in the "Keeping Your Own Shadow out of the Frame" section earlier in this chapter. However, there are times when shadows dappled on sunlit surfaces can be appealing to the eye. This image of a pile of watermelons illustrates how sunlit surfaces can draw the viewer into the frame. The sunlight that extends from the upper-left corner through the middle of the frame and down to the bottom right of the frame draws the viewer deep into the photograph. The image shows watermelons that are basically alike in shape and form, but different in terms of the amount of light that is cast on each one and in the orientation of the stripes that cover each.

More subtle is the varying sharpness of each melon. The ones that are the sharpest are near the top of the pile. They gradually become softer as you move downward in the frame. This is because the autofocus point was centered on the middle melons one-third from the top of the frame.

There's a rule that states that you shouldn't make what's in the foreground soft. Usually the eye prefers a sharp subject/object in the foreground with the background blurred so the emphasis is on the subject/object. I find that when you have almost identical subjects/objects, you can play around with your focus points, creating areas of sharpness and softness wherever you want, depending on how you want your viewer's eyes to move across the frame. To be sure, the left-to-right movement of the eye as the viewer looks at the photograph has him studying the orientation and brightness of each melon, but that's not how all people would see the image. Viewers who do not read from left to right (such as Arabic speakers) will view the melons from right to left, giving them a different perspective on the image.

Abandoned motel in Arizona.

Using a Shadow as the Main Subject of Your Photo

Supplemental Elements: multi-segment metering, spot metering, center-weighted metering
Location of Picture: Arles, France
Camera Settings: f/11, 1/500 sec, ISO 400, 200mm

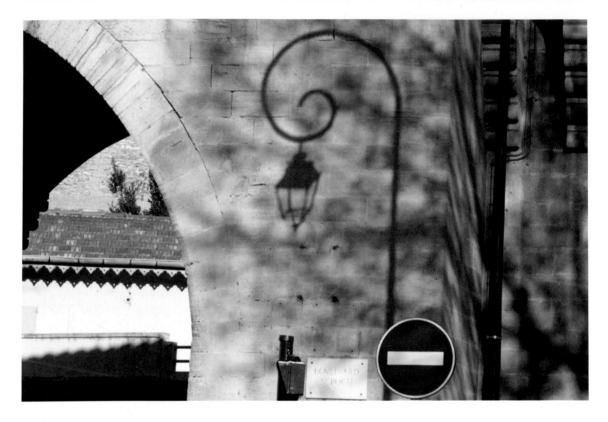

It's quite obvious that your first assumption when dealing with shadows is that they're produced with sunlight, which means there will be plenty of sunlight in the frame. That in itself would make for an easy time getting a sharp photograph. Almost any camera produces fast shutter speeds at most apertures in aperture priority mode when you're photographing a subject on a sunny day. Today's dSLR cameras will meter most scenes with the shadow as the main subject in both center-weighted metering and multi-segment metering.

The best time to get shadows that make up a winning photograph is on clear days just after dawn and before dusk, when the shadows are long. What makes this photo interesting is the realistic look of the post and lamp. When you first glance at it, you might think it is a real lamp or one drawn on the wall. In reality, nature drew it on the wall in the late afternoon on a winter

day. What makes the photo look real is that the lamp's shadow is cast in perspective on the wall, with each side of the glass divided by nearly vertical lines of different lengths. The bottom of each is connected by short, nearly horizontal lines at the bottom of the lamp.

METERING METHODS DEFINED

On most dSLR cameras, you have the option of choosing how the sensor will measure light. There are usually three options: multi-segment, center-weighted, and spot metering.

When the camera is set to multi-segment metering, it will measure the incoming light by evaluating each of a designated number of zones throughout most of the sensor area. In center-weighted metering mode, your camera will emphasize a zone in the center of the frame. The camera weighs exposure mostly in the center of your frame, with a little bit of weight given to the rest of the frame. If the area on which you want to meter is not in the center of the frame, you can make your meter reading for an off-center subject, then lock your exposure by pressing the shutter release halfway down and reframing the shot.

You can use multi-segment metering for most subjects and get a fairly decent image; however, I usually use center-weighted metering for most of my images. The exception is landscapes, for which I use multi-segment metering.

Last is spot metering. This is mostly used when you want to measure the light from the center of an object. The reading will weigh only in the center of the frame.

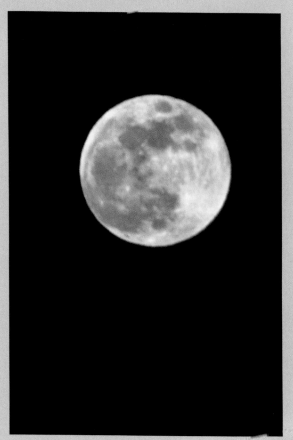

Picture of the moon taken when the camera was set to spot metering.

Again, if the area you want to meter is not in the center of the frame, you can lock exposure on objects that are off center and reframe. Spot metering is great for photographing the moon at night. If you are using spot metering for your moon photo, your camera's sensor will be taking in a lot of light, so you'll have to shoot in shutter priority mode, begin with fast shutter speeds, and work your way down to slower ones for the best exposure.

Finding/Creating Contrasting Color Backgrounds for Shadows

Supplemental Elements: foreground, background, exposure compensation
Location of Picture: Marrakesh, Morocco
Camera Settings: f/6.3, 1/640 sec, ISO 200, 70mm

If you can find a wall painted with a color other than white, you can transform it into a wall with two colors—one created by the direct sunlight on the wall, and the other created by a shadow cast on the wall. This picture shows a wall in Marrakesh with a shadow cast on it by the building next door. The shadow is interesting because it has openings of sunlight where openings in the building are. The building is in the walled city of Medina, a place where the walls are the same color, a very light peach tone. When shadows are cast onto these walls, they change to a muddy brown with peach overtones. There are many places in the walled city where one building casts its shadow on another. To make the shadow darker, I lowered my exposure compensation by one stop. At the bottom of the wall where the shadow is cast, the wall is very dirty. The shadow covers that up quite nicely. You'll find that the tones change over the course of the day as the sunlight waxes and wanes.

USING EXPOSURE COMPENSATION TO ENHANCE HIGHLIGHTS

Sometimes your camera will not get the exposure right in your shot. You can correct your exposure using the exposure compensation setting that is usually controlled by a dial on the top of your camera. On most cameras you can read the values (which range from –2 to 2) on your LCD screen. In pictures where you have very bright areas, you can make sure that the highlights keep their detail by lowering your exposure compensation a stop or two. However, using exposure compensation isn't as important as it used to be. If you shoot in Raw, you can change your exposure compensation after the fact in post-processing.

Walk of Stars, Hollywood, California.

Photographing Shadows of Dusk

Supplemental Elements: black-and-white photography, Photoshop, Camera Raw
Location of Picture: Paris, France
Camera Settings: f/6.3, 1/250 sec, ISO 400, 65mm

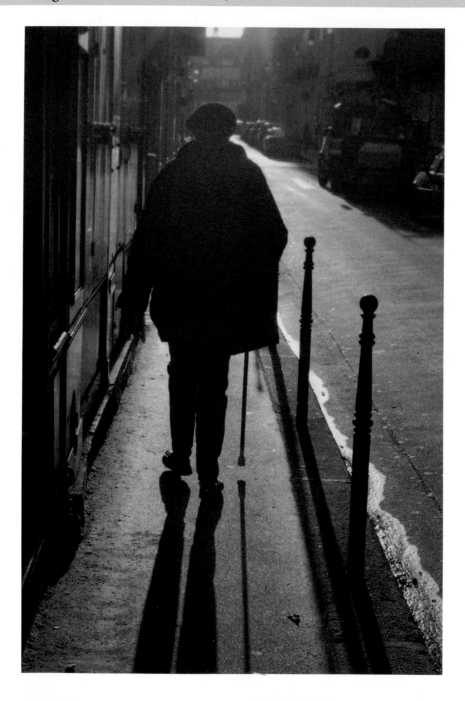

Without a doubt, Paris is La Ville-Lumière, the City of Light. Subjects walking down streets that look as if they end at the sunset or sunrise make for a fascinating photograph. I took this picture in Paris of a man who is walking toward the sunlight. The shadow of his legs and cane is remarkable because it forms a mirror image that looks as if it's coming up from the ground. This happens because the shadow is in the foreground. To get a picture like this, shoot about an hour before sunset or an hour after sunrise. Shoot toward the sun so your subjects become silhouetted, catching passersby between you and the sun. You'll be facing east to catch the sunrise shot and west to catch the sunset shot. Because this photo had very little color to begin with, I switched it to black and white, which is simple nowadays with a variety of image processing programs, such as Photoshop Elements and Photoshop.

One more note: You can choose to set your camera to take a picture in black and white, but if you do, no color information will come with it. In other words, you forever lose your chance of having a color photograph of the shot.

Row of phone booths in Antigua, West Indies.

Eliminating Shadows from the Frame

Supplemental Elements: foreground, background, exposure compensation
Location of Picture: St. Thomas, Virgin Islands
Camera Settings: f/6.3, 1/320 sec, ISO 200, 40mm

Occasionally you'll visit a place in the early morning or late afternoon when long shadows are cast that you really don't want to include in your frame. When you frame the picture, you might not notice these shadows, but you'll find out that they are there after you download the images onto the computer.

The first image here shows a wagon whose shadow is cast in the foreground of the frame. It isn't a pretty shadow, and there is really no way to crop it out. The only alternative you have with this shot is to reshoot in the morning—that is, if you'll be in there in the morning. If it were a partly cloudy day, you could wait for the sun to go behind the clouds to eliminate the shadow (or at the very least, soften it).

In circumstances when you have long shadows in, say, a park, you have to pick and choose what you're going to photograph in order to avoid getting foreground shadows in the frame. The second image here shows another wagon, which was situated in a way that there was no foreground shadow cast. (The shadow is under the wagon.)

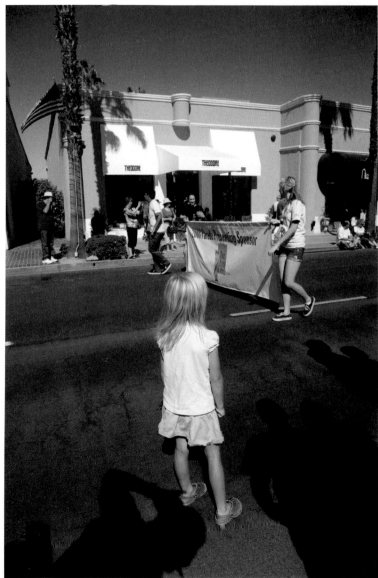

Parade in Palm Desert, California.

Framing Shadows So They Move from Foreground to Background

Supplemental Elements: aperture priority mode, composition
Location of Picture: Columbia, California
Camera Settings: f/10, 1/125 sec, ISO 200, 24 mm

It's been said that you should worry about the background as much as the foreground. Others have said that there is no distinction between foreground and background. This image shows a composition where the background is in focus, clearly a connection to the foreground, so that fence and house make up the subject of the photo. Indeed, in the photo, you can say that there is no distinction between foreground and background. Following the fence provides the payoff of a house. While the vertical lines are symbols of strength, the strength is offset by the diagonal lines—the boards that hold up the fence.

So, what is the purpose of the shadow that leads from foreground to background? It provides a set of horizontal lines that adds further dimension and depth to the photo. It also emphasizes the line at the base of the fence, which together with the other lines leads to the house.

Little girl twirling as seen from above.

Finally, it "colors in" a design in what would have been a large area of low contrast (not much contrast between the yellow and brown of the dead leaves and the green nearly-dead grass). The dark lines give a sense that the frame is full, that all parts of the space in the frame have been used.

To get a sharp shot from foreground to background, I used a narrow aperture and shot in aperture priority mode. Because this is a handheld shot, I didn't use an aperture narrower than f/10, because the shutter needed to be open longer to get the right exposure. When the shutter is open longer, there's more of a chance of getting camera shake blur.

Books as buildings, a form of programmatic architecture, in Aix-en-Provence, France.

CHAPTER 5

Making Art from Architecture

A rt and architecture go hand in hand, especially when it comes down to photographing buildings, monuments, bridges, and other structures. Capturing the best of an architect's design in an artful way takes skill and talent—both qualities that can be learned though practice. Sometimes you have to step away from a building to free yourself from the lens distortion that comes with photographing a building up close. Other times you have to hone in on a sculptural or other element to show off its detail. However you go about photographing architecture, feel free to try new angles and perspectives to make your work stand out from the rest. In this chapter, we'll focus on the basics of architectural photography. In other chapters of the book, I also include architecture as it relates the other aspects (light, shadow, symmetry, and so on) of creating winning photos.

Using a Tripod to Photograph Buildings at Night

Supplemental Elements: shutter speed, shutter priority mode, focal length
Location of Picture: Disney Hall, Los Angeles, California
Camera Settings: f/13, 3.2 sec, ISO 200, 24mm

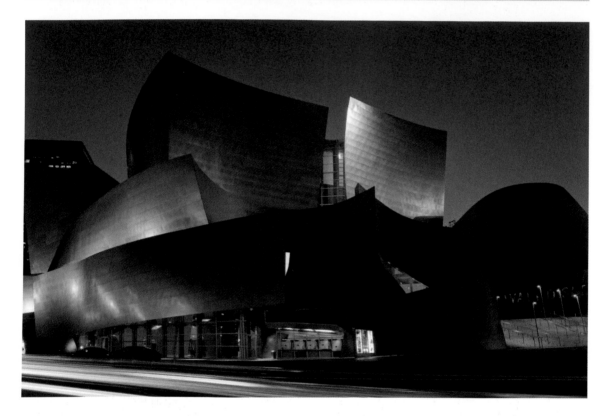

Architect Frank Gehry designed Disney Hall, which opened in 2003. The stainless steel–paneled building was designed to look like a sailing ship and is one of the best architectural photo ops in the world. Isolating this structure so that only it appears in the frame is dependent on how far you are from it and what focal length you are using. To take the photo of Disney Hall shown here, I had to stand across the street and use the widest angle on my lens, which corresponds to the smallest focal length—I used a Canon L-series 24-105mm lens and shot at 24mm. A 24mm focal length shoots at a fairly wide angle—wider than, say, the smallest focal length you'd have on a point-and-shoot camera or on a telephoto lens. You'll need to walk farther down the street to get the entire building in the frame if you have, say, a 35mm lens, which is about as small a focal length as point-and-shoots and some telephotos have.

During the day, shooting the Disney Hall is simply a matter of placing it tightly in the frame and setting your aperture to around f/8, so that the entire building stays in focus, including the folds of steel that are on top of and in back of the building. At night, shooting is a bit more of a challenge, but it's also a whole lot more fun.

First, you'll need a tripod. Then you need to walk to the part of the building you see in the right side of the frame and cross the street. If you can, get there just when the sun sets. You'll get that really deep midnight blue from a half hour to an hour after the sun sets. After you set up your camera and tripod on the street corner, set your camera to shutter priority mode. (See the "Using Shutter Priority Mode" sidebar.) In this mode, you'll set the shutter speed, and your camera will determine the aperture.

Next, set the self-timer (which delays the shutter opening after you press the shutter release) so you don't get blur from the camera shake that can happen when you press the shutter release button. Now you're ready to shoot.

Experiment with a variety of shutter speeds, starting out at perhaps 1/8 of a second and gradually going up as the sunlight wanes. You can also use manual mode and change either the f-stop or the shutter speed to change the exposure or set the camera for AEB, automatic exposure bracketing. No matter what mode you use, you'll end up taking at least a dozen pictures of this monument, each with slightly different lighting.

Finally, go home and pick out your best picture. You won't be disappointed with the results!

USING SHUTTER PRIORITY MODE

If you have a camera that lets you shoot manually (meaning it has a manual mode, a shutter priority mode, and an aperture priority mode), you can fine-tune just how much light you let into your lens. First, set your camera to shutter priority mode (Tv or S mode). Then, set a shutter speed value. On a good dSLR camera, the values will run from 1/8000 second (the camera will display just the denominator of 8000) to 30 seconds (the camera will display the number followed by a quotation mark, such as 30"). The lowest value indicate the shortest time the shutter stays open, and the highest value indicates the longest time the shutter stays open. When your camera is in shutter priority mode, it determines the aperture according to what shutter speed you've chosen to give you the best exposure. The shot of fireworks pictured here required a long shutter speed of 4 seconds. When you photograph fireworks, you must experiment with shutter speeds in Tv mode. For brighter fireworks displays, you need a bit faster shutter speed, and for dimmer displays, you need a longer shutter speed.

Photographs of fireworks require long shutter speeds.

Avoiding the Use of Flash When Photographing Building Interiors

Supplemental Elements: ISO speed
Location of Picture: Peter and Paul Cathedral, St. Petersburg, Russia
Camera Settings: f/4, 1/40 sec, ISO 400, 32mm

With today's digital camera technology, finding alternatives to flash photography has never been easier. If you have a dSLR camera, you can get sharp photographs in low light without flash by following three steps: 1. Set your camera to aperture priority mode; 2. Set your aperture to its widest setting; 3. Set your ISO speed to at least 400.

When you set your camera to aperture priority mode, you determine the aperture, while your camera determines the shutter speed. When the aperture is open wide, more light gets through so that the shutter speed will be faster, hopefully giving you a sharper image. By setting your ISO speed up a bit, you further increase your chances of a getting a sharp image. I composed this image of Peter and Paul Cathedral with a tight focus so that viewers can look at the chandeliers and move their eyes upward along the cables that connect them to the ceiling, and then along the ceiling to the lower-right corner of the frame where there is a payoff—a fresco on the back wall.

SHHH! COME INSIDE, BUT PLEASE NO FLASH

What's a photographer to do when he's given a once-in-a-lifetime photo op, and he has no more than 60 seconds to use it? He makes sure that the ISO speed on his camera is set high. That's what happened in Myanmar, when I peeked into a classroom at a Buddhist temple, held up my camera, and got approval from the teacher to come in and take a picture. Since I already had my camera set to aperture priority mode and set to the widest aperture, I was ready to go...except for one thing: I needed to turn up my ISO speed. I quickly set it to 1600, went in, and took the shot. In case you were wondering, I don't like to shoot with flash, especially when I'm in a sacred, quiet place, such as a Buddhist temple.

So just what is ISO speed? Formally, it's called the *ISO equivalent*, and it is a measure of how sensitive your sensor is to light. The higher the ISO speed, the more sensitive the sensor is to light. The most important thing to know about ISO speed is that the higher it goes, the more susceptible your image is to noise—those annoying colorful little dots that can appear on your photo if it's afflicted.

Looking for Architectural Style

Supplemental Elements: ISO speed, architectural styles
Location of Picture: Basilica del Voto Nacional
Camera Settings: f/22, 1/160 sec, ISO 800, 17mm

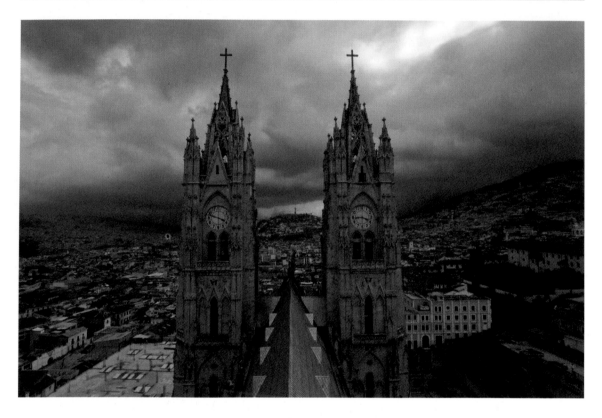

To find and identify an architectural style is to get the real story behind a building's history. This is so true for the Gothic style, which fills the imagination with suspense and even horror. Gothic architecture is just one of dozens of styles that you can learn to identify when you travel. (See the "Architectural Styles Tell a Story" sidebar for more information about architectural style.)

There are a couple of things going on with this shot of a Gothic church that are of interest. The entire landscape is in sharp focus because of the narrow aperture I used when shooting the picture. I wanted viewers to see the monument on the top of the hill on the horizon in the far background of the frame. This monument marks the general location of the equator. If you look from between the spires to the point where you see the monument in the distance, you're looking east, so that on the right side of the photo is the Southern hemisphere and on the left side is the Northern hemisphere.

The access to get to the place where I shot this photograph is a bit harrowing. The climb up to the point where I shot was treacherous—steep stairs that soar to the sky—not to mention frightening, but it was well worth it. The views are incredible, and there's a special treat: You get to see the world sliced in half.

ARCHITECTURAL STYLES TELl A STORY

The Gothic style dots the great cities of the world—Paris, New York, Vienna—with towering spires, pointed arches, ribbed vaults, and flying buttresses. The Basilica del Voto Nacional is similar in design to the Notre Dame Cathedral in Paris. The difference between the two is that Notre Dame is an original Gothic structure, completed in medieval times, and the Basilica is a recreation of the Gothic style, or Gothic Revival, which became popular in the late 1800s.

There are dozens of architectural styles to look for when you're photographing buildings. Some are associated with architectural movements started by royalty and others by religious figures, not to mention the many that were conceived by the great architects of the world. This image shows Marmorkirken, the marble church in Copenhagen, Denmark. It's a good example of Baroque architecture, which has its roots in Italy. Other types of architecture include: Medieval, Romanesque, Tudor, Mediterranean, Victorian, Beaux Arts, Art Nouveau, Art Deco, and Bauhaus.

A Baroque marble church with a dome in Copenhagen, Denmark.

Including Exterior Fixtures in the Foreground

Supplemental Elements: composition, architecture types
Location of Picture: City Hall, San Francisco
Camera Settings: f/9, 1/200 sec, ISO 200, 35mm

Many public buildings contain beautiful exterior fixtures and/or fountains that can be placed in the foreground of your photographs, adding more depth than if you had just photographed them alone. In many cases the fixtures are of the same or similar architectural design as the nearby building. The lamp and the building in this image are part of the San Francisco City Hall complex. Both are Beaux Arts–style architecture, and they are a subtle match in shape and form. The lamp is elongated, as are the columns on the building, along with the more obvious matching gold metalwork on both the building and the lamp.

Not only do you have similarities, you also have differences. The lamp is a shade of dark blue and contains curlicues, which contrast the building's strict stone surfaces and linear forms. I used relatively narrow aperture to make both the lamp and the building sharp.

Expo 67 structure in Montreal, Canada.

Filling Your Frame with Architectural Detail from an Old Building

Supplemental Elements: aperture, symmetry, color
Location of Picture: Marrakesh, Morocco
Camera Settings: f/7.1, 1/200 sec, ISO 800, 120mm

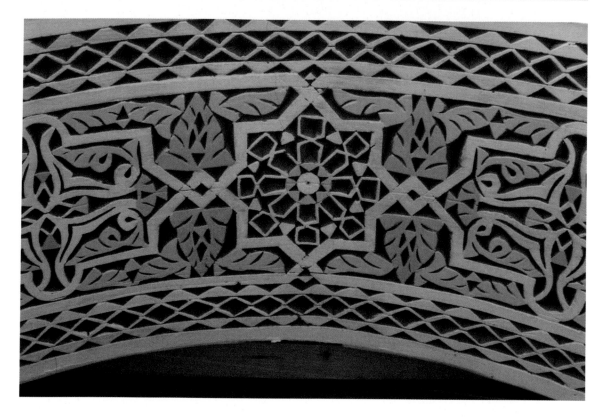

An ornament can be anything really that adheres to a building, such as woodwork, sculpture, tops of columns, and cornices. If you happen to be in an Arab country or neighborhood, you'll find Islamic artworks similar to these—colorful and filled with symmetry. Islam bars the use of animal or human figures in works of art. Much of the art consists mostly of calligraphy and geometric designs. You won't find art that tells a story.

The art has origins from before 1000 A.D. It's not that the Qur'an forbids figures. What it does specify, however, is that images are not to be worshipped or idolized. Only Allah is to be worshipped or idolized, and the Qur'an is the story. Art is used to enhance the environment,

playing a secondary role. As you can see in this image, the designs are very elaborate—it was a labor-intensive process to make it, to be sure. To take this picture, I used a zoom lens because the decorative trim of which this art was a part was up one story. I had to step back a distance so as not to get a distorted picture from my camera angling up.

PHOTOGRAPHING THE ARAB WORLD

If you're photographing in an Islamic country, the same general rules apply as anywhere else in the world—ask before you photograph a person (and sometimes have money ready if that's what the person wants) and be careful not to photograph military bases and some government buildings. Finally, if you see women in various forms of traditional clothing and try to photograph them, they'll let you know their disdain if they see you. In the Islamic world, your best bets are photographing their art and architecture. You'll be rewarded with some stunning and often surprisingly revealing photographs of the Arab world. This image shows some art that was found on the walls in Medina in old Marrakesh.

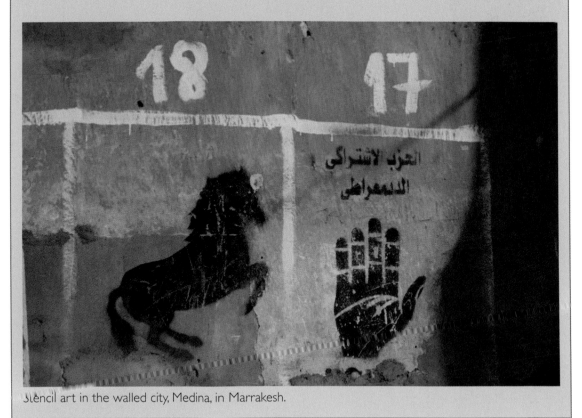

Stencil art in the walled city, Medina, in Marrakesh.

Creating Dramatic Converging Lines in Architecture

Supplemental Elements: composition, architecture types
Location of Picture: Chicago Water Tower, Chicago, Illinois
Camera Settings: f/9, 1/30 sec, ISO 400, 18mm

I didn't get the composition in this Chicago Water Tower shot by accident (although that happens, too). I walked around the building looking though my viewfinder to find the most interesting composition. I tilted my camera up and to the side at different angles.

I found this angle interesting for a number of reasons. Not only are the converging lines leading the eye upward, but the shape of the building causes the eye to stop at the top of the tower. If you observe closely, there's the unusual effect of both the converging lines and the shape of the building forming a triangle out of the building. I also found a good angle to pick up the light in the windows so that you get a sense of depth with respect to the inside of the building because the lights are on, giving an illusion of an invitation for viewers to peek inside. Finally, I found that the other elements of the photo—the tree and the high rises in the background—don't interfere or take away from the main subject of the shot (the water tower) because they have a silvery cast, which blends into the sky, which, in turn, contrasts with the adobe brown of the building.

Some of the drama of this shot can be attributed to the wide angle that I used. Indeed, I had switched lenses from my all-purpose lens to my wide angle before taking the shot. As for the Water Tower—it was completed in 1869 and designed by architect William W. Boyington. The look is medieval, even castle-like. Formally, it's Castellated Gothic, according to the City of Chicago government website. If you look closely at the image, you can see the architectural details, which include pointed arches, a sawtooth roofline, and corner turrets.

DIVERGING LINES

Just as tilting your camera upward will produce converging lines that slope inward bottom to top in your frame when you are photographing from the ground near a building, tilting it downward will cause the lines to slope outward. So when you're way up high—say, photographing through a window from one of those rooftop restaurants that are ubiquitous in and around the big cities of the world—you'll get a diverging effect. This is an effect that some viewers might not notice if you don't point it out.

Looking down on buildings in Shanghai, China.

Take a look at this high-rise shot. The buildings spread out as you move up from the ground to the roofs and converge inward If you look down from the roofs to the ground. Either way, it makes for an interesting photo if you ignore the rule that the converging lines need to meet at a point within the frame. In this photo your eyes are led from top to bottom, to far below the ground in the center of the earth! Just in case you are wondering, this is a picture of downtown Shanghai. The place is booming with state-of-the-art high rises.

Eliminating Converging Lines in Architecture

Supplemental Elements: composition, shadow, architecture types, Photoshop
Location of Picture: Union Station, Los Angeles, California
Camera Settings: f/5.6, 1/1000 sec, ISO 100, 100mm

To avoid getting converging lines in this shot, I walked away from the building, keeping in mind that I was going to capture the tower with a vertical shot. As soon as I saw the sun shining brightly on the building's façade, not to mention the palm trees casting their shadows on it, I'd have a winning shot. The tall, skinny trunks of the palms are almost comic-like and are most certainly a well-known symbol of Los Angeles. Union Station in Los Angeles had its heyday in the 1940s, before the automobile became king. The exterior of the building shown in this image has elements of what would be considered Mission Revival architecture. The style is an imitation of the architecture of the California missions that were built up and down the California coast beginning in the 1700s.

Just in case you have a compelling shot with converging lines, all is not lost—you can correct them fairly easily in Photoshop. To fix the pesky lines that come together:

1. Open your image.
2. Select it using the Rectangular Selection tool.
3. Choose Edit > Transform > Skew.
4. Click and drag each corner outward until the lines are straight up and down. You can use the Guides in Photoshop to help you get the lines exactly up and down. First, make sure the Rulers are shown in the window (View > Rulers), then click and drag a Guide (it will be light blue) from the vertical Ruler to near the converging line.

KEEP THE FOCUS ON PART OF A BUILDING

Another way you can eliminate converging lines is to focus on just a part of a building. In this shot, I photographed the temple in Myanmar at an angle, but I kept my camera from tilting up or down or to either side so that the vertical lines in the wood-work and around doorway are straight up and down.

There is one more thing going on in this picture that is of note. The first is the boy in the doorway. If you can get a person to fit within your architectural photo so that it's aesthetically pleasing and offers some contrast, by all means do so. If you can fit a person into a doorway, you'll add interesting dimension to your photo.

Boy looks out from temple doorway.

Eiffel Tower, Paris, France.

Creating Mood Shots Using Weather

There's a saying that everyone talks about the weather, but nobody does anything about it. It seems to me that photographers are doing something about the weather all the time. They express feeling with different weather events. There's a certain mood communicated in almost every outdoor shot you take, from joyful sunny skies to sad, lonely foggy days. Each shot uses a different technique, from how you frame a shot to what settings you'll use. No matter what the weather is, the photographer out in the field experiences the invigorating feeling of being in the great outdoors.

Making a Daytime Clear Sky Look Deep Blue

Supplemental Elements: composition, color, exposure compensation
Location of Picture: St. Thomas, U.S. Virgin Islands
Camera Settings: f/7.1, 1/250 sec, ISO 200, 67mm

Built in the 1600s, Fort Christian, shown here, is the oldest building in St. Thomas, U.S. Virgin Islands. The red building offers compelling contrast to the blue Caribbean sky. The first thing you need to do to get a photo like this (and you can get one with just about any historical building if the weather's right) is to shoot at the right time of day. The sun must be behind you when shooting to get the deepest blue in the sky. If the sun isn't behind you but is out of the frame, attaching a circular polarizer to your lens will help to make the sky a deep blue. If you shoot with the sun in front of you (even if it's behind the building), you'll get blown white highlights. Sometimes those highlights can be nice if you position the sun strategically for an interesting shot. (See the "Using Blown Highlights to Create a Compelling Photo" sidebar.)

The second thing you need to do is to frame the shot vertically with only a part of the building in the frame with nothing else—no surrounding buildings, trees, telephone wires, and so on. You can frame using the Rule of Thirds so that the building takes up about two-thirds of the frame and the sky one-third, also showing some sky in the right side of the frame, as shown here.

Finally, you can also deepen the blue by lowering the exposure compensation a stop or two. In doing so, all the colors in the frame will deepen. You can also do this in an image processing program. If you shoot in Raw format, you can lower the Exposure slider in the Raw window. If you shoot in JPEG, you can move the middle slider in the Levels dialog box to deepen the colors. There's more information about file types later in the chapter.

USING BLOWN HIGHLIGHTS TO CREATE A COMPELLING PHOTO

Just as you can create a deep blue sky by shooting with your back to the sun, you can create an interesting blown highlight by shooting with the sun in front of you. To make the blown highlight from the sun disperse light so that the photograph is compelling, you have to frame the shot so that the sun is behind part of the building, as shown here. This involves walking back and forth from the subject/object until you get the sun where you want it when you are shooting. After you shoot, check your LCD screen to see whether you got the look you like. If not, move around and shoot some more. Remember, never look directly into the sun.

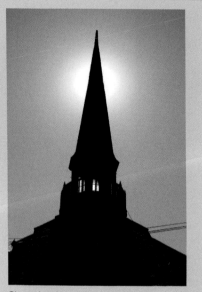

Shooting into the sun creates an interesting effect.

Showing Wind by Including Blowing Sand in the Frame

Supplemental Elements: focal length
Location of Picture: Santa Monica, California
Camera Settings: f/5.6, 1/1600 sec, ISO 100, 200mm

Usually windy days aren't all that good for photographing landscapes because trees blow and then blur in your image. If you're at the beach and there are no trees, you can get a compelling photograph when the wind whips up the sand. It helps, too, if you finish off the composition by waiting for a couple of seagulls to fly into the frame as well as people walking into it, as shown in this Santa Monica shot.

To get the effect—one that presents itself in a thin layer of sand just above the surface of the beach—you have to take the picture some distance away from the shore so that the sandy beach, ocean, and sky are the only elements in the frame (along with whatever objects/subjects are in the air or on the beach). You don't want a road, a sidewalk, or any other obstructions in the foreground. Then you have to zoom into a section of the beach to get the layer of blowing sand thick enough so you can see it. I zoomed in to a focal length of 200mm, and that did the trick in terms of getting the sand to show up.

AFTER THE HURRICANE

There are dozens of weather events that you can photograph. They include:

❄ Lightning

❄ Cumulonimbus clouds (thunderstorm clouds)

❄ Tornados and funnel clouds

❄ Dust devils

❄ Sandstorms

❄ Snowstorms

❄ Ice storms

Although photographing during an event will often lead to a riveting photo, you have to be careful not to damage yourself or your camera. For example, you don't want to bring your camera outside when temperatures are well below 0 degrees Fahrenheit, nor when sand is swirling around you. You can, however, photograph through the windshield of your car or through a window inside. To get the best photographs, make sure these windows are clean inside and out. Finally, don't forget the damage done after the storm. There's nothing like a photograph of trees bent from the weight of ice or signs bent and trees ripped to shreds from the winds of a hurricane, as shown in this shot.

You can show the damage from strong winds in your frame.

Including Different Shades of White in Snow Photos

Supplemental Elements: blown highlights, exposure compensation
Location of Picture: Desert Hot Springs, California
Camera Settings: f/8, .6 sec, ISO 100, 28mm

Nobody likes blown highlights—blasting whites or other colors that cause a good part of an image to lose its detail. A picture without blown highlights, like this one of white mountains and windmills, is filled with white areas that give details of the terrain with varying shades of white. The different shades of white are made by shadows of different shades and changes in light shining on the snow covering the rolling hills' crests and troughs. The picture without the windmills shows areas of blown highlights in the snow on the mountains in the background. The biggest area of blown highlights is just left of the right side of the frame.

One way to prevent blown highlights is to underexpose your photo. The only drawback in doing this is that the entire frame gets underexposed, meaning that the foreground will also be too dark. A better way to prevent blown highlights without sacrificing the exposure of the foreground is to use a circular polarizer. (See "The Wonders of a Polarizing Filter" sidebar in Chapter 11, "Composing with Landscapes.") I used a circular polarizer when taking the picture with the windmills. It provided a filtering of light that helped to eliminate blown highlights in the snowy mountains.

SNOW'S MANY FACES

There are all kinds of ways to photograph snow. You have to assess what's in your frame and how much light there is. I caught the snow as streaks in this shot of a homeless woman in snowy Paris. The streaks add a sense of despondence to the weather.

I've prevented blown highlights in the frame by using a colored filter instead of a polarizer. In the color version of this shot, I used a blue filter. When I converted this picture to black and white, the snow showed all sorts of light-gray tones. A black-and-white photo of something like this is what people often see in museum documentary photography shows.

To shoot a picture like this, set your camera to aperture priority mode at a wide aperture. The camera will set the shutter speed fast enough to give

Falling snow shows up as streaks in this picture of a homeless woman in Paris seeking refuge from the snow.

you a sharp shot, yet still have the snow streaking around the frame. If your frame is filled with snow all around, your camera's light meter will underexpose the shot (your shot will appear darker than normal). To prevent this, you can increase your exposure compensation by one stop. For more about exposure compensation, see Chapter 4.

Photographing Wet City Streets from Above

Supplemental Elements: shutter speed, long exposures, motion blur
Location of Picture: San Juan, Puerto Rico
Camera Settings: f/5, 1/30 sec, ISO 200, 105mm

If you happen to be in a high rise—say, the 10th floor of a hotel room—you've probably got a chance to get some great photo ops, whether it be of a city skyline or a street scene below. If it has rained, you'll have the opportunity to catch a glowing reflection of whatever's on the ground looking as if it's below the ground. I shot this image from the pool area of a hotel in San Juan, Puerto Rico. It had just stopped raining, so I was able to get maximum reflections from the wet city street below. There were dozens of people lining up to get on a cruise ship. The reflection of the people replaces what would have been their shadows if it had been sunny. Notice, too, the man walking in the bottom of the frame. His reflection is sharp and isolated, making it almost mirror-like. I used a tripod for this shot because it was late in the day and my shutter speed was a bit long. Note that the longer the shutter is open, the more people will be blurred. (See the "Movement Blur: People on the Go" sidebar.)

MOVEMENT BLUR: PEOPLE ON THE GO

How far does a person walk in two seconds? If you want an answer to that question, set your shutter speed to two seconds. Of course, exposure isn't all that simple. If you set your shutter speed to two seconds in shutter priority mode on a sunny day, you'll get all white in your frame (as well as a blinking aperture value on your LCD screen, which indicates your camera can't calculate a proper exposure). If you set your shutter speed to around two seconds at a narrow aperture in shutter priority mode at dusk, you'll get an image with motion blur when photographing people walking, as shown here. Since it's still light outside, your camera will come up with a narrow aperture for the two-second exposure.

Oh, yes, the answer to the question: A person walks anywhere from 5 to 15 feet in two seconds. You can guesstimate that value by looking at the paths people made in this shot.

Slow shutter speeds will cause movement blur.

Using Black and White for Weather Photographs

Supplemental Elements: black-and-white photography, Camera Raw, Photoshop, Photoshop Elements
Location of Picture: San Juan, Puerto Rico
Camera Settings: f/5, 1/3200 sec, ISO 200, 24mm

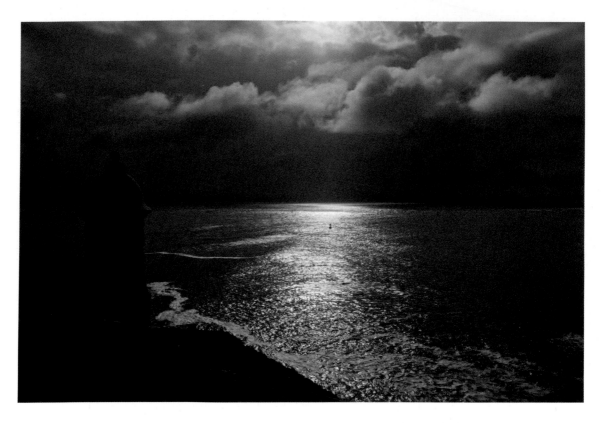

It makes no sense these days to take a picture in black and white when you're out in the field. Why would you want your camera to make decisions on the gray tones when you can do it with a number of image processing programs? Shoot in Raw, and you've got sliders that let you adjust a number of parameters for your black-and-white images. Remember, too, if you didn't shoot in color, you won't have color anymore.

In Photoshop's Raw dialog box, all you have to do is take down the saturation to 0 using the Saturation slider. Then you can adjust exposure, recovery, fill light, blacks brightness, contrast, and clarity. Other programs can do it with the click of your mouse; however, be forewarned—you want more control of the tones than what just an image processing program's software can do for you.

In this shot, my goal was to not have any blasting white highlights in the ocean. Even though my image as shot showed some, I was able to tone them right out of the photo by using the Raw sliders in Photoshop. If you don't shoot in Raw, use the "convert to black and white" options in Photoshop (Image > Adjustments > Black and White) or Photoshop Elements (Enhance > Convert to Black and White).

USING CAMERA RAW TO DO IT ALL

Camera Raw format has all the saved sensor data from when the image was shot. Raw files—or *digital negatives*, as some people call them—are large files that contain details of what your camera has shot.

Cameras can also save pictures as JPEG files. Unlike Raw files, JPEGs have already been manipulated by your camera at the time the picture was taken. When you go to edit your photo in Raw, you can do so without as much degradation of your image as when you edit a JPEG file.

Each camera company has their own type of Raw file, but Photoshop and Photoshop Elements will open all the ones from the major companies. Photoshop and Photoshop Elements open Raw files in a special window. Within that window are a slew of options with which to tweak your photo. Under the first tab (the basic tab), there are sliders with which you can tweak your image's temperature, tint, exposure, recovery, fill light, blacks, brightness, contrast, clarity, vibrance, and saturation. There are other tabs, too, in which there are even more options to help you get as much image detail as possible. If you have an interest in photography, you'll want to get a camera that shoots in Camera Raw.

Wet night in Rome.

Having Your Camera Ready When Clouds Put on a Show

Supplemental Elements: point-and-shoot camera, resolution
Location of Picture: Palm Springs, California
Camera Settings: f/15, 1/8 sec, ISO 100, 200mm

The first thing you'll probably ask about this shot is, what is it? It's a lenticular cloud. The cloud is called *lenticular* because it's shaped like a lens. The cloud is formed by strong winds over the tops of mountains. The picture was taken near the top of San Jacinto Mountain in Southern California. I shot this image with my Sony DSC-H5 point-and-shoot camera—a camera that I have with me at all times. My other camera, a Canon 5D, is too bulky to carry all the time. The Sony camera that I shot the cloud with is known for having a great zoom. I was glad I had that capability at my fingertips because the cloud was a bit of distance away from where I was walking, and I was able to zoom into it to catch it close up.

The camera also has a good image stabilization system, but in no way does it take as sharp an image as a dSLR camera. People often mistakenly think that some point-and-shoots take just as sharp photos as a dSLR camera because they have just as many (or more) megapixels. Nothing could be further from the truth. You can easily understand the shortcomings of point-and-shoot cameras when you view images shot from one at 100-percent resolution on a computer screen. Images from point-and-shoot cameras will have a graininess that keeps an image from being sharp. You can't see this when an image is set at 20-percent resolution, which is the resolution at which most people view their images. The lack of sharpness is due to the tiny size of the sensor. The sensor on the Sony DSC-H5, for example, is only a sixth of the size of one on a full-frame sensor camera, such as the Canon 5D. Most dSLRs have larger sensors designed with larger pixel sites than those found in point-and-shoot cameras, and that gives them more resolution regardless of the pixel count.

Putting all this aside, an image shot with a point-and-shoot is better than no image at all, especially when the clouds put on a show like in this shot.

Color cloud show over the skies of Bangkok, Thailand.

Photographing Umbrellas Open in the Rain

Supplemental Elements: composition
Location of Picture: St. Lucia, West Indies
Camera Settings: f/7.1, 1/20 sec, ISO 200, 24mm

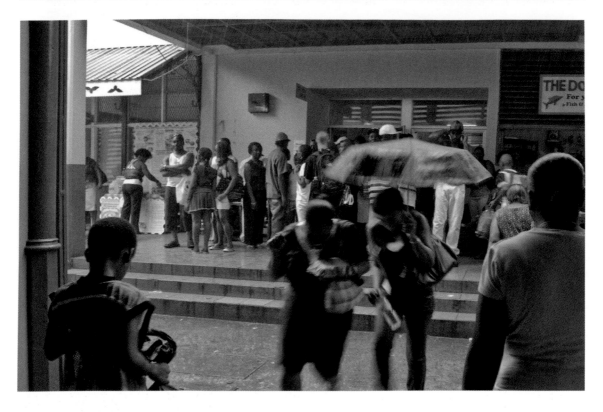

Have you ever waited for the rain to let up, only to have it rain harder? It can be a game of cat and mouse. You end up watching people taking a chance on getting wet as they go out and run for it. Only the brave and daring will take a step out into the pouring rain without waiting for it to stop. When you're under a canopy or awning waiting for the rain to stop, pull out your camera and photograph those who take a chance on getting wet. You'll create a mood of urgency in your photograph by including subjects who are running out into the rain, attempting to stay as dry as possible.

When taking the shot, the setting isn't as important as the rate of rainfall. For the rainfall to show up in the photo, it has to be heavy—a real downpour. This West Indies shot shows some people making a run for it during a brief but furious downpour in the Windward Islands.

While others waited for the rain to stop, I waited for it to get heavy. I wanted to catch at least a few groups of people running into the downpour. By taking many shots, I'd have a selection of shots from which to choose the best ones.

In this shot, you can only see the rain at the top of the frame, where it contrasts the dark-brown roof of the building, and on the ground, where the drops spread out into circular patterns. If you're photographing the rain, the best chance of a correctly exposed shot comes by setting your camera to a wide aperture. You'll end up shooting quickly, as people will dash out into the rain in a flash—sometimes when you least expect it.

UMBRELLAS AREN'T ALWAYS FOR RAIN

Most of the time we associate umbrellas with rain. But in this shot of a single umbrella taken in Antigua, West Indies, there is an oxymoronic statement that associates the text "sunny" with a bright, multicolored umbrella. In truth, umbrellas are used to protect oneself from the rain as well as from the sun. In marketplaces throughout the world (especially the Third World), umbrellas are used to set up makeshift storefronts on the street.

When I took this shot, I had to make my way around several umbrellas set up in front of the store. I first started photographing the umbrellas in front of the "Sunny" store as I approached it from across the street. But I found the composition to be inadequate in the shot with two umbrellas because of the clutter in the left side of the frame from the surrounding buildings. I found that if I moved to where the sign "Sunny" begins, I could create a much better composition by including only the sign and one umbrella in the frame.

Where you photograph a scene from makes a big difference in composition.

Using Fog to Create Mystery

Supplemental Elements: composition, exposure compensation
Location of Picture: Lands End, San Francisco, California
Camera Settings: f/5.6, 1/250 sec, ISO 100, 205mm

When it's foggy outside, you can create mysterious compositions. In this picture at Lands End in San Francisco, I've shot two boulders with a space between them, through which you can see a third boulder in the fog in the distance. The first thing I thought of when I was out taking this landscape of the rock triad is the Three Graces—mythological goddesses of charm, grace, and beauty. The painter Raphael also represents the Three Graces as three voluptuous naked women standing close together. Since fog conjures up images that are dreamlike, you can use your photographs of subjects and objects in the fog as elements for storytelling. It's all in how you compose the elements in the fog and what you know from past experiences and education as to what narrative you'll create. Like snow and sand, fog can fool your camera's light meter, resulting in an underexposed shot. To add light, you can increase your exposure compensation by a stop or two.

A perfect day at the Wigwam Motel in Arizona.

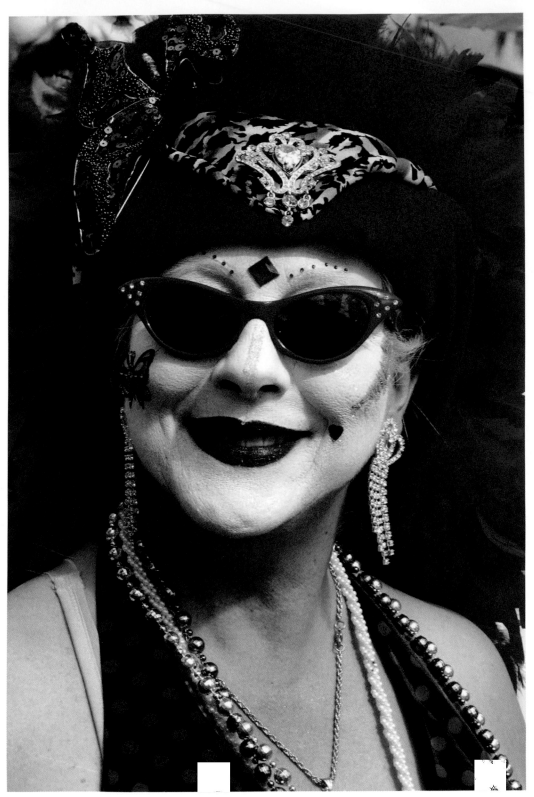

Dressed for color.

CHAPTER 7
Beautifying with Color

Never has there been a time when the choices of color have been so varied. With digital photography, you can produce almost any color that exists. With so many options, where do you start? The options begin when you shoot. How you set your camera will determine what colors you get. How you frame your shot is your presentation of color. After you take the shot, your options for manipulating color are limitless with Photoshop and other image processing programs. Be careful, though, and don't let these options overwhelm you. You may be tempted to tweak color. This temptation should go unfulfilled, because the key principles of color can be stated in three words: Keep it simple. From shot to print, having a simple plan for the colors of your shot is just one more step to creating a winning photo.

Filling a Frame with One Color

Supplemental Elements: color, auto mode, focal length
Location of Picture: Paris, France
Camera Settings: f/4, 1/90 sec, ISO 100, 50mm

Peering through a bakery case at pale yellow icing slathered on top of a cupcake is my idea of heaven. Add to that a candied citrus ornament in the middle of the divine creation, and you've got a photo op that's sure to get mouths watering.

Filling a frame with one color gives your image a special focus. In terms of composition, when a good part of the frame contains just one color, most of the work is done with respect to composing your image because that one color becomes the focus of your shot. The pale yellow of the cupcakes stands out as a major focus of the photograph. If the cupcakes were different colors, you'd lose that effect.

Not only is the color unique in this shot, but so is the method with which I got this photo. To shoot these cupcakes so that there wasn't glass in the way, I decided to hand over my digital camera to the baker behind the counter so she could take a picture of them without the interference from reflections on the glass case I was looking through to see the pastries. No, I didn't take the photograph here—the baker did!

Handing over your camera isn't a bad idea if you think someone is in a better position than you are to get a picture. Before I handed the camera over, I set it to auto mode and then estimated and adjusted the focal length to get a close-up shot. The baker didn't have to do anything but press the shutter release all the way down.

Akatombo or Japanese Red Dragonfly.

Using Color to Make Subjects/Objects Pop Out of the Frame

Supplemental Elements: aperture, depth of field
Location of Picture: Paris, France
Camera Settings: f/4.5, 1/100 sec, ISO 400, 70 mm

Seeing red on a cold, snowy day can warm the soul. This image shows a red rose and green stem, which appear to come out of the frame because of their relationship to the neutral colors around them. The red rose is a sign of respect for the deceased. Symbolism aside, this shot was taken when it was overcast, so there are no shadows. If it had been sunny, the shot would have had a different effect. The clouds also kept the snow from melting. Because I used a wide aperture, there is blur in the hand that rests in the foreground. (A wide aperture produces a shot with a narrow depth of field.) Like the colorful rose and stem, the hand adds further dimension to the image.

WHAT COLORS MEAN

You've seen that the rather bleak graveyards of Paris are dotted with color. Color that is surrounded by muted browns and grays can burst out of the frame no matter what angle you shoot at. You wouldn't know that it was oppressively hot and humid when this picture of two people sitting in chairs on a Cartagena, Columbia, street was taken because the blues in the image cool the frame.

Colors communicate feelings, which develop narratives in your photograph. Following are some associations that can be made with each of the colors:

✳ **Red.** Red is an attention getter, warming up your photographs. Put red in your photo, and that's the color people will notice first. Of much interest to photographers is the fact that red is the first color that disappears at dusk.

✳ **Blue.** Blue is a stable color, calm and soothing. It gives a cool feeling to your photographs. You'd never know that it was extremely hot and humid in this shot. As I mentioned before, the giant blue door in the background of the Cartagena street scene image cools the frame.

✳ **Yellow.** Yellow is bright, energetic, and happy. It's a stimulating color relating to the sun. Yellow wakes you up and picks you up.

✳ **Green.** Green is a healing color. It soothes and makes us feel better when we're down, a regenerative kind of feeling.

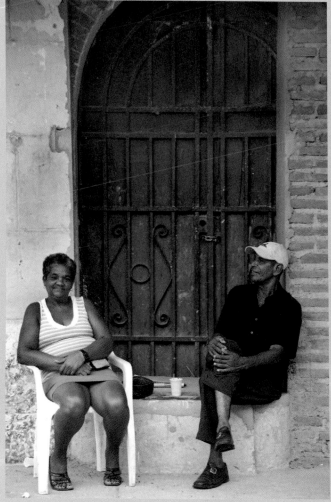

Blues cool the frame.

Framing Contrasting Colors

Supplemental Elements: color, composition
Location of Picture: St. Martin, West Indies
Camera Settings: f/5, 1/4000 sec, ISO 400, 24mm

Colors that sit opposite each other on a color wheel are complementary. In photography, we call them *contrasting* colors. The best contrast for the color red is green; for yellow it's purple, and for blue it's orange. In this picture of the beach on the Dutch side of St. Martin, you have bright orange umbrellas contrasting the aqua water and the bright blue sky.

The beach is located about a block from the downtown area of the capital, Philipsburg. Had I framed the shot at any other angle, objects in the water would have interfered with the shapes and forms of the deck chairs and umbrellas. What I did was frame the picture so those objects are blocked (covered up) by the umbrellas. I wanted the focus of the picture to be on the deck chairs, umbrellas, sea, and sky. Notice, too, that the deck chairs have an orange cast from the umbrellas above them, which enhances their presence in the frame. To enhance the color of this shot, I used a circular polarizing filter.

Yellow seeds contrast other colors in the frame.

Making Each Color of a Rainbow Show Up Clearly

Location of Picture: Paris, France
Camera Settings: f/5.6, 1/2000 sec, ISO 800, 180mm

Rainbows appear in the sky when millions of water droplets act collectively to form a prism through which light passes and then is reflected. The light gets divided into a spectrum of colors, which are the colors of the rainbow. (See the "Rainbow: Now You See It, Now You Don't" sidebar.) They are best photographed in front of uncluttered backgrounds. When shooting rainbows, you want fast shutter speeds because you don't want to risk blur in the landscape, nor do you want have too much light to mute the colors. It's nice to have a payoff at the end of a rainbow. Ideally, it should be a pot of gold, but if not, frame an object at the rainbow's end. This shot shows a rainbow in Myanmar that ends with a boat in the water.

RAINBOW: NOW YOU SEE IT, NOW YOU DON'T

Just what are the colors of a rainbow? You'll find red, orange, yellow, green, blue, indigo, and violet (in that order) in all rainbows. All of these colors come from white light, according to Sir Isaac Newton, who defined the colors of the rainbow with respect to white light centuries ago. In reality, there are an infinite number of colors because of the way the colors meld from one to another.

Rainbows come and go, and as they form they reach an apex of brightness and then they fade away. Some form and die quickly; others stick around for a while. Rainbows can form almost anywhere, from high in the sky to hugging the ground. One incredible day—February 8, 2008—a series of rainbows formed throughout the Southern California deserts. From stunning double rainbows to rainbows pressed against mountains, I'll never forget that day. I had my point-and-shoot with me while on my way to a hike in the high desert. While traveling through Desert Hot Springs, California, I found a rainbow that looked like a bridge over the road. That was the most incredible rainbow I've ever seen, and I screeched my car to a stop to photograph it. I turned down my exposure compensation two stops to bring out the colors of the rainbow. (You can also do this in an image processing program after the fact.) Indeed, I was in the right place at the right time for this rainbow shot.

A "rainbow bridge" that formed over a road in Desert Hot Springs, California.

Taking Close-Ups of Fruits and Vegetables

Supplemental Elements: color, background, focal length
Location of Picture: Cartagena, Columbia
Camera Settings: f/5.6, 1/125 sec, ISO 100, 230mm

The most important thing to do when photographing an arrangement of fruits and/or vegetables is to have the background as uncluttered as possible and to have it blurred. To blur the background and keep the subject sharp, step back from the arrangement and then zoom in (use a long focal length) with your camera so that it is tightly in the frame. This image shows a fruit arrangement where I found an angle to get an uncluttered background and stepped back to zoom in to get the background blurred.

The next thing you want to consider when photographing fruits and/or vegetables is their insides. The inside of the fruit can be more interesting and colorful than the outside. If you look at this shot, you'll see that the fruit has been cut open so you see its brightly colored pulp contrasting dark seeds. There's a narrative here, too. Although this arrangement looks as if it was created haphazardly, which makes it interesting, its shape and form come from a rational process. If you look hard enough, you'll see the skin of an orange without the pulp as well as the rind of a slice of watermelon. This tells you that the person selling this fruit takes a piece out, cuts or peels it, and gives the portion to the customer.

Organic carrots at the Farmer's Market in San Francisco.

Making Stubborn Greens Come Alive

Supplemental Elements: color, polarizing filters
Location of Picture: San Juan, Puerto Rico
Camera Settings: f/5, 1/80 sec, ISO 200, 58mm

Oh, those greens! Trees, plants, bushes, lawns, grass, meadows, and forests offer color challenges to the photographer. Any green area in a photograph can appear with blue tones—so much so that you can hardly tell whether there's any green there. This is because the blue sky reflects off the green of plants, creating a blue-green color that's not all that attractive. When oriented in certain specified ways (90 degrees from where the photographer is shooting to the sun in the sky), polarizing filters can turn away the blue skylight so that plants appear more green. (See the "Use a Polarizing Filter to Get Rid of Glare" section in Chapter 11.) In this shot I took in San Juan, I used a polarizing filter to cut out the reflected glare off of the palm fronds, leaving them a stunning green. A polarizing filter will slow down your shutter speed a bit, so it's best to use focal lengths less than 75mm, where you'll get the least amount of blur in your subject. Also, the sun was shining on this palm at an angle of 90 degrees from where I was standing. This made the polarizer really effective. The sunlight shining directly on the tree helps, too.

Green growth covering ground at the ruins of Tikal in Guatemala.

Creating Blasting Colors from Murals and Graffiti

Supplemental Elements: color, wide angle lens, Raw format, Photoshop
Location of Picture: Christiana neighborhood, Copenhagen, Denmark
Camera Settings: f/5.6, 1/250 sec, ISO 200, 24mm

Deep in the heart of Copenhagen is Christiana, a neighborhood of 85 acres where one can wander the paths where hippies roam. There's plenty of graffiti there, to be sure, and it's meticulously painted, as shown in this image.

There was a time when the only way you had to deepen colors was to underexpose by bringing down the exposure compensation a few stops, but that time is quickly passing. You can just as easily reduce the exposure in an image processing program. If you take a picture in Raw format, tweaking the exposure to make the colors blast is a one-step procedure in Photoshop. All you do is move the exposure slider in the Camera Raw window.

I like to include plants (if there are any) or other objects in the frame when taking a picture of a wall full of graffiti. In doing so, I put some originality into the shot instead of just shooting someone else's artwork. Often graffiti will extend a good distance along a wall, much more than you could include in a frame. If you want to catch as much of the spray-paint art in the frame as you can, use a wide angle lens. Finally, if you publish a picture of graffiti, even on a blog or a website, give the artist credit if you know who he/she is.

Graffiti at Copenhagen train station.

Matching Photo Sets by Color

Location of Picture: various places around the world
Camera Settings: various settings

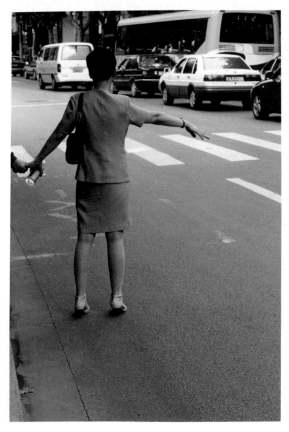

Pretend you're at a gallery and the theme is Blue. Every piece of art has to be blue. The room would be filled with coolness. Grouping photographs by color is a natural match for a photo set. These four unrelated photos have one thing in common—the main subjects/objects are all a shade of blue. This is a real way to play with color. When you look at the set, you come to the realization that there are a lot of shades of blue. It's a real study in color. You can do this with any of your favorite colors.

There's one more thing: The color you choose gives the set a certain feeling. To learn about the feelings for each color, see the "What Colors Mean" sidebar earlier in this chapter.

PHOTO SETS

A *photo set* is created when you match aspects of one photograph with that of another photograph or photographs. I'm sure you've been in hotels or restaurants that have a series of images—all related—on their walls. And, you probably also know that if you can sell one image that's popular, you can sell many that are similar to it. Another useful element of creating photo sets is that matched photo sets on a webpage make it more readable when the photos are accompanied by text.

There are many ways you can match your photographs with each other. Consider these:

1. A butterfly, person, or any other subject shown from different angles with the same background.

2. Photos with the same hues and tones, perhaps taken in the same city at a certain time of year, such as Paris in the winter, and even taken using the same camera settings.

3. Things that are related to each other in some way, such as a series of machines, radios, signs (of course!), and vintage autos.

4. A set of pictures taken in real time, one after another in burst mode—perhaps two birds interacting or a set of images with soccer players' moves every fraction of a second. (For more information about burst mode photo sets, see the "Finding Acts of Affection" photo op in Chapter 3.)

5. Pictures of different parts of an old abandoned building or house or the streets of a big city. The colors and hues will be similar, but the light, shapes, and forms will vary with each photo in the set. I've seen these types of sets in many art shows.

Finding Color Shades and Tones You Haven't Seen Before

Supplemental Elements: color, patina
Location of Picture: Angangueo, Mexico
Camera Settings: f/8, 1/80 sec, ISO 100, 100mm

Sometimes you'll find planks of wood exposed to ultraviolet radiation from the sun, which causes the wood (or paint) to degrade. During this process it changes color. The wood is said to have *patinaed*. The colors that you get after wood degrades might be ones that you've never seen before. If you look at this shot from Angangueo, you'll find that the planks of wood that make up the gable of the roof range from gray to Caribbean blue. In this shot taken near the spot in Mexico where thousands of butterflies come in the spring, I framed just the multicolored wood. Three colors of note here (ones that took well to the sensor) are the light gray near the top of the gable, the bright robin's-egg blue further to the right, and the very light pink on the right side of the building. Beautiful colors can be found on old wooden buildings almost anywhere in the world.

Using a Macro Lens to Photograph Flowers

Supplemental Elements: focal length, color
Location of Picture: Quito, Ecuador
Camera Settings: f/4, 1/125 sec, ISO 100, 100mm

One the best photographs you'll take with a good point-and-shoot camera is a close-up using its macro feature. Although it isn't formally a macro lens, it does a darn good job of photographing up close. Other than that, a dSLR camera with a good macro lens attached will do the trick. Formally, macro photography is when the subject/object of your photograph is as big as the image being projected onto your sensor. That lens is called a 1:1. A macro lens with a focal length of about 100mm is perfect for photographing flowers up close. This shot shows an orchid photographed with a 100mm macro lens at the Quito Botanical Garden. Notice the deep colors and the sharp detail of the flower. The flower petals look almost as if ink were blotted onto them.

Woman in water in Myanmar.

Breathing Life into People

The world is teeming with people—nearly 7 billion of us, each person different in many ways. To compose a shot with one person or more is to evaluate the light, background, and color of the shot. Then you have to set your camera for just the right exposure. While a family portrait in front of a well-known landmark can be fun, opening up your world to anybody and everybody that interests you expands your photography vision. Whether it is a candid shot or a posed one capturing the fine details—from slanting shoulders to sharp focus on the eyes—taking an extra effort to think about what you want in your photo will only make it better.

Blurring the Background in Portraits

Supplemental Elements: aperture, depth of field, focal length
Location of Picture: Bagan, Myanmar
Camera Settings: f/6.3, 1/125 sec, ISO 400, 350mm

Portraits look great if you can get the subject sharp and the background blurred. Many photographers like 85mm lenses for portraits. They are usually fast lenses—they have wide apertures so that shutter speeds need to be fast for proper exposure. Also, with some digital SLR models you have a smaller sensor, so many photographers use a 50mm prime lens that gives them a high-speed short telephoto of 75mm, given the crop factor. The generous aperture of a 50mm lens can also deliver a nice blurred background when used at wider openings. The first thing you want to do to take a portrait with a blurred background is to position your subject. Place him in front of a background that's not busy—that is, one that doesn't have a lot of clutter or objects with dark lines that can take away the focus from your subject.

Next, you need to move away from your subject. Look for a spot several feet away and then try zooming in on him with a large focal length. If you zoom in on your subject, and you see only eyes and a mouth, you need to walk farther away—far enough away that you can frame him with some space above his head and so that some of his shoulders are included in the bottom of the frame, as shown in this image of a boy in Myanmar. When you and your subject are in a good position for the shot, you need to set your camera to aperture priority mode. You should set your aperture to the lowest value that's possible at the focal length you are using for the lens you have. (See the "Camera Lenses and Focal Lengths" sidebar.) Finally, take your picture.

CAMERA LENSES AND FOCAL LENGTHS

When you go to the camera store to buy a lens, you'll find the focal length or range of focal lengths on the box as well as on the barrel of the lens. The values are written as f-stops on the lens. You have to remember that the larger the f-stop, the smaller the lens opening. For example, a lens that has an f-stop that opens the aperture wide—say, to 2.8—will let more light through than one that is 5.6.

Wide apertures can freeze action.

Lenses that open to wide apertures are considered fast lenses because when the apertures are open very wide, the shutter speed has to be faster. A lens with a minimum f-stop of 2.8 can use a faster shutter speed to allow more light to hit the sensor than a lens with a minimum f-stop of 5.6 for the same exposure. With a fast lens, it's much easier to freeze subjects when they are moving quickly, such as a couple of soccer players trying to get control of the ball, as shown here. Also, when the aperture is open wide, the ISO speed (a measure of the sensor's sensitivity to light) can be set lower for better-quality images.

Zoom lenses can have one aperture for all of the focal lengths of the lens. For example, I have a 24-105mm lens (24-105 are the focal length values) with a minimum f-stop value of f/4 at all focal lengths. There are other types of zoom lenses whose minimum f-stop values can range, say, from f/4 to f/5.6—that is, their minimum f-stop values change gradually as you zoom in on your subject.

Having Subjects Slant Their Shoulders and Turn Their Head in Different Ways

Supplemental Elements: histogram, exposure, focus lock
Location of Picture: Yangon, Myanmar
Camera Settings: f/5.6, 1/400 sec, ISO 800, 45mm

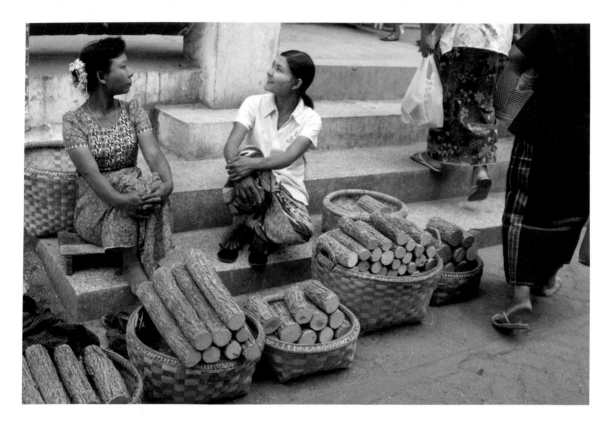

Subjects placed in a frame need not be symmetrical—that is, subjects don't need to have their faces facing the camera with their shoulders making a perfect horizontal line within the frame. Whether you're taking a candid or a posed shot of people, how they are situated in the frame is important. Notice the position of the subjects in this image taken in Myanmar. The woman on the left has her head turned to the side so that she appears as a profile in the frame. Both women's shoulders slant, each at an opposite direction from the other. The slant of the shoulder changes the orientation of the body, providing for a more interesting pose. Last is the fact that the women are facing each other in similar positions, which in effect unites them in the composition.

STRIKE A KILLER POSE

If you're framing a model or subject, you can help him strike a pose that's fit for a winning photo. If you usually have your subject just stand with his hands by his sides, his body will form a series of straight vertical lines, which doesn't make for an interesting photo. Here are some different poses that will vary the shapes and forms to help liven up a portrait:

✳ Have the subject bend a knee and put more weight on the back leg when standing straight up.

✳ Position the subject with one hand in his pocket and the other on a bent knee.

✳ Have the subject sit at a table with his/her arms resting on it.

✳ Position the subject facing the frame with one hand on a table and the other by his side.

✳ Position the subject's hands so the edges face the lens.

✳ Have the subject spread his fingers just a bit to give detail to the hand.

✳ Frame or crop your photo above or below joints that connect limbs.

Don't crop your image where limbs are connected by joints.

✳ Have the subject turn his/her head so about three quarters of it is visible in the frame.

✳ Have the subject tilt his/her head slightly.

✳ Talk to the subject while you are taking his portrait to create natural expressions.

✳ Have the subject sit with his/her legs crossed.

✳ Have the subject fold his/her arms.

These subjects automatically crossed their legs and arms when I took their picture.

Putting Subjects Close to the Lens

Supplemental Elements: barrel distortion, wide angle, focal length
Location of Picture: Ft. Lauderdale, Florida
Camera Settings: f/3.5, 1/40 sec, ISO 100, 35mm

You can achieve a cool special effect by placing your lens close to your subject when you're taking a picture. It produces a subject that is inflated at the center of the frame. To get the most exaggerated effect, shoot at a wide angle (less than 35mm) and place the lens near your subject's face. If you step far away from your subject and zoom into him with his face near the lens, you won't get the effect because the entire frame is already magnified by the telephoto lens. In this picture of my nephew that I shot in Florida, the subject's face is very close to the lens so it appears inflated in the middle. While this effect is good if the subject just poses for the shot, it's even better if the subject is doing something, such as drinking from a straw.

Set the focus point on the eyes when photographing close up.

Using the Subject's Body to Create Different Lines and Angles in the Frame

Supplemental Elements: silhouettes, close-ups
Location of Picture: Palm Desert, California
Camera Settings: f/4.5, 1/800 sec, ISO 200, 73mm

Lines are everything when it comes to silhouetted portraits. If you trace the lines in this shot, you'll find that they curve in and out, creating an interesting composition. The railing also adds more lines to the composition, not only because the rails are thinner than the lines made by the boy's body, but also because of their orientation. I made sure that the horizontal lines making up the railing lined up with the guide in my viewfinder so that they didn't tilt down or up. However, if you don't get the lines aligned properly out in the field, you can always rotate the frame in an image processing program later.

The horizontal lines convey a sense of stability and restfulness. There are more lines, too, in the railing—lines that create a kind of optical illusion. If you look at the picture long enough, the railing can appear as if it's behind the boy, leaving the boy floating in the air.

JUNGLE RED: PLACE FOCUS ON OTHER BODY PARTS

Upon close inspection of this shot of a woman with her fan, you find that the nails polished in jungle red mark the center of the frame, putting focus on what might otherwise be considered a mundane body part. The face isn't the only part of the body that can be the center focus of a photo. You can zoom in on other body parts, such as nails, hands, and feet, especially when other elements in the frame add to their significance. The woman's hand is aesthetically significant not only because of the red nails, but also because of the jewelry she is wearing—ring, watch, and earring—which forms a triangle in the frame. The background, too, adds to the depth and color of the photo—the man's vertically lined orange, yellow, and blue shirt, as well as the man with the hat in the far-right corner.

A woman uses a fan to protect her face from the sun.

Placing Subjects Off Center in the Frame

Supplemental Elements: Rule of Thirds, lighting
Location of Picture: Just outside Guadalajara, Mexico
Camera Settings: f/3.5, 1/125 sec, ISO 200, 180mm

For the best composition, place your subject just to the right of the center of the frame. While many photography books recommend that you place your object a third off from the right side of the frame, it doesn't have to be exactly one third, especially if you're framing the shot vertically, like this one of a woman in Mexico.

This subject was photographed late in the day, inside a food stand with only three walls and a ceiling that was fully open to the outdoors at the entrance, with only a gate to lock it up at night. The woman was standing against a north-facing wall inside the restaurant just as the sun went down. The natural lighting at that moment was perfect—a shot without shadows and so clear she almost seems as if she could walk out of the frame after she's finished posing.

The woman is wearing an apron, which is part of the attire she needs to wear as a cook in the restaurant. Part of the charm of the picture is that the apron doesn't match her dress. Another significant aspect of this woman is that even though she is older, her skin is flawless, smooth, and tan, without any blemishes or age spots. It's the kind of subject you could look at for a long period of time and be enamored by what looks to be a very nice, kind, ordinary Mexican woman.

Human sign in Vancouver, B.C., placed off center.

Bouncing Light onto Subjects off a Whiteboard

Supplemental Elements: lighting, portraits, outdoor photography
Location of Picture: Demuth Park, Palm Springs, California
Camera Settings: f/4, 1/320 sec, ISO 250, 105mm

If you've ever wondered whether a whiteboard reflects additional light when you're shooting outside at dusk, you needn't wonder anymore. It does so effectively. The first shot here, with the man tilting his head slightly to his right, shows the subject with a whiteboard placed just above the waist angled up toward the chest and face. The second image shows the same subject without the whiteboard. The whiteboard provided an even layer of white light over the subject's upper body and head.

There is one drawback to the whiteboard: You can see its reflection in the subject's glasses. You probably wouldn't have noticed that had I not pointed it out. There's a pretty obvious solution to this problem—have the subject take off his glasses. You can also try playing with the angle of the reflector to minimize its reflection.

You can also use a whiteboard to augment indoor light. The best light to use indoors would be indirect sunlight coming through a north-facing window. A reflector can also be used with lamp light or flash.

Natural light, setting, and pose make for a compelling photo.

Placing Two or More Subjects Close Together

Supplemental Elements: balance, portraits, outdoor photography, metering, close-up photography
Location of Picture: Indio, California
Camera Settings: f/5.6, 1/160 sec, ISO 400, 100mm,

The first thing you'll probably notice in this shot (other than the subjects being placed together) is that one subject is above the other in an almost perfect balance of figures. Also significant are the smiles; their similarity adds to the balance of the frame. The girls are wearing orange and blue clothing—colors that are opposite on a color wheel, which makes them complementary.

The background is important here, as well. The camera was held high so that there is only grass in the background. Not only is it green, it's also textured and softened by zooming in the lens on the subjects. Finally, the lighting is very even. There you have it in a nutshell: When you place people in a frame, watch for two subjects' closeness, balance, facial expressions, clothing (color), and background.

WHEN SETTING YOUR CAMERA TO EVALUATIVE METERING IS A MISTAKE

Metering your scene—that is, adjusting from where in the frame the light comes into your lens—is easy as changing a camera setting. All dSLR cameras have metering systems. The systems measure light available in the frame.

There are three or more settings on your dSLR camera from which you can choose to meter your picture. One way is to set it to *spot metering*, a metering system where the camera meters a small area around a focus point in the frame. (For more about metering, see "Metering Methods Defined" in Chapter 4.)

Many photographers often leave their camera set to center-weighted metering. They do this because they don't want the camera to make decisions for them as it would when it's set to evaluative metering. This image shows a two-subject portrait with a sharp background and poorly lit subjects. It was shot when the camera was set to evaluative metering. This caused the light meter to place too much emphasis on the background of the shot. For the subjects to be properly lit, the camera should be set to spot metering or center-weighted average metering.

Subjects can appear dark when taking portraits with evaluative metering.

Finding Offbeat People Doing Strange Things

Supplemental Elements: candid photography, ISO speed, aperture priority
Location of Picture: Guadalajara, Mexico
Camera Settings: f/5.6, 1/160 sec, ISO 400, 100mm

Going for a drive? If you are, don't forget your camera; otherwise, you might miss getting a photo like this shot of a fire-eater. On Guadalajara roadways there are street performers doing odd and offbeat things. You just don't expect a fire-eater to be in the middle of the street, except maybe in the movies.

When you are shooting candidly, set your ISO up a bit—say, to 400—to eliminate the blur from camera shake. Sometimes you'll have to get out the car quickly at a stoplight, as I did to get this shot. Other times you can photograph as a passenger. (See the "A Moment in Time" sidebar.) Finally, keep your aperture wide open in aperture priority mode. This will let your camera decide on faster shutter speeds in yet another process to ensure a sharp photo.

A MOMENT IN TIME

Have you ever been a passenger in a car or bus in a traffic jam in a busy area of town? If so, you have a golden opportunity. In this shot taken in St. Petersburg, Russia, you get a real feel for the Russian people from the photograph of random people standing on a street corner. Notice the clothing, the ethnicity, and the ages of the people. Do they look different than people where you are from? Is there a Russian characteristic you can name that's common among all the people in the shots? Perhaps to you, the people look as if they could be from any Western city in the world. However many questions you have about the photo, it's a great thing for the photographer. He has kept your attention on his photo for longer than just a glimpse.

Street corner in St. Petersburg, Russia.

Camel in Cappadocia, Turkey.

CHAPTER 9
Making Animal Photos Sharp and Fun

If you've ever looked at photos of animals in *National Geographic*, you know how captivating they can be. Of course, it would be nice if you could emulate those photos, but not many people get a chance to go to the faraway places where these animals thrive. However, there are ways you can get similar pictures. The first option is to go to the zoo. But don't only go to your local zoo—go to different zoos when you travel, because each zoo is drastically different, and you might be able to get a photograph at one zoo that you can't get at another. To make your pictures look as if they were shot in the wild, get your hands on a zoom lens, invest in a tripod, and take lots of close-ups. Your pictures of animals will not only satisfy the shutterbug in you, but will endure for generations, awing your children, grandchildren, and beyond.

Photographing at Developing-World Zoos for New Perspectives of Animals

Supplemental Elements: aperture, depth of field, ISO speed
Location of Picture: Yangon, Myanmar
Camera Settings: f/5, 1/60 sec, ISO 400, 35mm

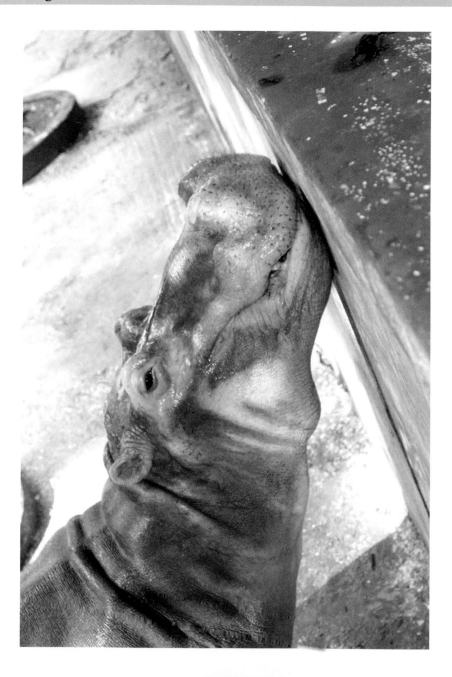

When it comes to zoos, strict standards rule in the Western world. In the larger cities and capitals of the developing world, the interaction between animals and humans isn't as limited. Granted, conditions at some zoos are abhorrent, but I won't go into that here. The Yangon Zoo, Myanmar's only zoo, is wide open, and you can get close enough to some of the animals that you can pet them (if you dare). The best exhibit at the zoo was the hippos. (See the "Inside the Hippos' Mouths" sidebar.)

I shot the image here with the aperture wide enough to get the entire animal in focus. Most important is that I didn't use a flash, because it would have spooked the animal. Instead, I increased my ISO speed just a bit. If this animal looks happy to you, you can rest assured that it was one of the happiest hippos I've ever seen.

INSIDE THE HIPPOS' MOUTHS

In the United States, most zoo exhibits are made to simulate the animals' real-life environments. The exhibits are vast areas of simulated landscapes—so vast that sometimes it's hard to see the animals, much less photograph them. In the developing world, the animal enclosures tend to be smaller but more accessible. And while many zoos in the United States don't permit you to feed the animals, other zoos around the world do. For example, in the Yangon zoo, you can buy sugarcane to feed the hippos. You can touch the animals if you want, because their enclosure is just a pit right underneath where you stand to observe. You just stick the sugarcane in the hippos' mouths, and voila—they munch it up.

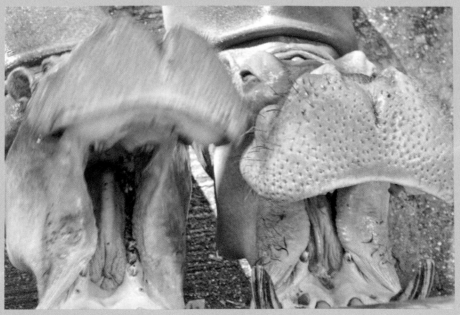

Hippos eating sugarcane in Yangon, Myanmar.

Using a Tripod to Photograph Zoo Animals

Supplemental Elements: color
Location of Picture: Jurong Bird Park, Singapore
Camera Settings: f/6.3, 1/125 sec, ISO 400, 450mm

Let me begin by saying that I don't think I've ever seen a "zoo" as beautiful as the Jurong Bird Park in Singapore. Although the park is limited to only birds, the limitations end there. From flamingos to parrots to eagles, like the one shown here, the park contains a variety of birds from all over the world.

Singapore, situated near the Equator, has intense sunlight when the sun is shining. When the skies are overcast, though, there is still very bright, even light without shadows almost everywhere you shoot, whether in or out of the shade. When you have light like this, it's almost perfect for a portrait of an eagle. Not only do you have light evenly spread over the subject, but you have a subject who wears a feathered suit. Notice the off white of the head from the "shoulders" up and the dark brown below. Here, nature has provided a handsome object in great light. One nice thing about zoos and animal parks is that using your tripod isn't a problem. You can set up shop just about anywhere you want. If you find yourself getting blurred pictures from your

zoom lens at places like this, consider taking along a tripod. Many animals in animal parks stay stationary for long periods of time, so you can catch them with a zoom lens at shutter speeds longer than 1/200 seconds, giving a crystal-clear picture with fine details.

THE RELATIONSHIP BETWEEN SHUTTER SPEED AND FOCAL LENGTH

Have your shaking hands ever caused your pictures to blur? There's a term for this—*camera shake*—and it happens to the best of us. I'm going to talk about some of the implications of camera shake and how it's related to both focal length and shutter speed. I'll spell out everything step by step so you don't get confused.

You probably know that fast shutter speeds freeze motion, and long shutter speeds can blur moving objects. In general terms, the longer the shutter is open, the greater the chance of blur from camera shake. Other variables also can affect blur caused by camera shake. The most significant is the focal length at which you are shooting. Changing lenses or using a telephoto lens and zooming in or out can change focal length. When you zoom out from an object, you get a wide angle of view (the object is smaller in the frame while more content around it is included in the frame). When you zoom in on an object, the angle of view is smaller.

Suppose you have a lens with focal lengths ranging from 28mm to 300mm. You're more likely to get blur from camera shake when the lens is zoomed in to a subject at 300mm than when it's zoomed out from an object at 28mm. When you zoom in on an object, it's like looking at it through binoculars. The more you're zoomed in on an object, the more it shakes from the object being magnified by the lens.

There's a little formula you can use to determine whether you'll get blur from camera shake. Note that it's just a rough guide because the way one person shakes is very different from the way another person does. The formula says that in order to get a sharp picture, the shutter speed should be less than the inverse of the focal length. A 300mm focal length needs to be handheld at a shutter speed of 1/300 second or less. (Less would be on the order of 1/400 second to 1/4000 second.) In other words, if you're zooming in on an object at 300mm, and your shutter speed is 1/125 second, like in the picture of the eagle earlier in this chapter, you're going to get blur from camera shake because the shutter speed is greater than 1/300 second. In the image in this sidebar, you see a picture of an ox taken in Myanmar. No tripod was used to take this picture because the ox was taken at a focal length of 105mm and the shutter speed was 1/500 second, which was less than 1/105 second.

No tripod was needed here because the camera was not zoomed in on the ox.

Photographing Animal Whiskers and Other Body Parts Close-Up

Supplemental Elements: color
Location of Picture: Chinese Hat Island, Galapagos Islands
Camera Settings: f/5.6, 1/500 sec, ISO 200, 168mm

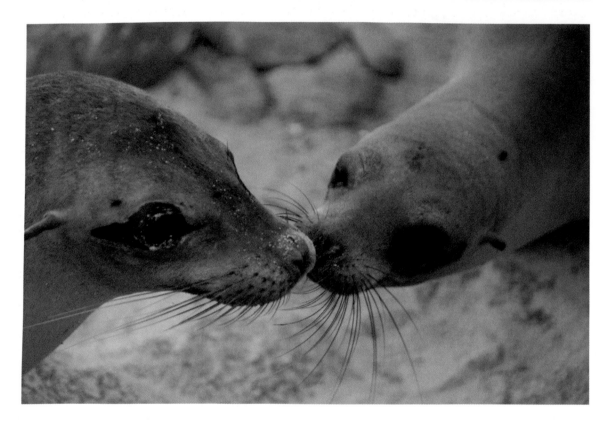

Have you ever looked at your pet and noticed its whiskers? They make up interesting curved lines that stick out into the air. By focusing on this body part in your photography, you'll have viewers aware of an animal part they probably don't think much about, yet they might wonder about.

While whiskers on most mammals help them to navigate through their environment, whiskers on seals help them to find prey under the water. Fish leave a trail in the water, and the seals' whiskers can follow it. This shot shows two seals that look like they could be giving each other a kiss. The whiskers figure prominently into the photo. Animal close-up pictures are great to sell as stock photography. For more information about that, see the "Consider Stock Photography for Your Winning Photographs" sidebar.

CONSIDER STOCK PHOTOGRAPHY FOR YOUR WINNING PHOTOGRAPHS

Anything you photograph that offers an interesting perspective to viewers can be a potential stock photo. Stock photography is becoming very popular for both buyers and sellers of photography. Online stock agencies, such as dreamstime.com, istockphoto.com, and shutterpoint.com, can sell your photos to their clients, which consist of publishers, ad agencies, and others who need photos quickly. Every site works differently in assessing your photos. Most are very selective. The number-one thing you should make sure of before you submit photos to these agencies is that your image is sharp when viewed at 100 percent in an image editor. Some agencies will give you valuable feedback about your photos, offering suggestions on how to improve them so they can be accepted on their sites. This image, showing a blue-footed booby from the Galapagos Islands, was accepted by a stock agency because it is both unusual and sharp.

This photo was accepted to sell on a stock photography site.

Showing Off the Texture of a Reptile's Skin

Supplemental Elements: color, texture
Location of Picture: Cabo San Lucas, Mexico
Camera Settings: f/9.5, 1/350 sec, ISO 100, 74mm

Here's a note from my journal about this image: "Here's a reptile I found sitting on a man's shoulder at port in Cabo. The guy kept wanting me to hold it so he could make some money from me. I really didn't care about the money, but I sure as heck didn't want to hold that thing. Can't tell you why, either. I usually love animals. Guess furry ones are more my thing."

My guess is that many people share my feelings about reptiles, but you've got to admit, they make very interesting specimens for photography. If you look at this shot of an iguana closely, you'll see the detailed patterns that make up the iguana's skin—details that make the photo compelling. You can also see that in some areas the skin is a bit loose, just like human skin gets. I framed this iguana tightly, including only half of his body in the picture. In so doing, viewers are able to get a real feel for the texture of the reptile's skin.

The best part of the picture is the difference in texture and in the patterns of the skin on its body compared to the skin on its legs. Snakes, lizards, and other reptiles have similar interesting patterns on their skin that you can photograph if you so dare.

Finally, notice the man in the background—he fills what would have been blank blue space, balancing the composition of the photo.

The many textures of an ostrich's head.

Photographing Pets at Eye Level

Supplemental Elements: candid photography, color, shapes
Location of Picture: The Grove, Los Angeles, California
Camera Settings: f/4, 1/500 sec, ISO 400, 1/1250 sec, 50mm

There's nothing worse, I believe, than a picture of the top of a dog looking up. To capture a pet in its full glory, stoop down and get on its level. You can do this with your own pet or other people's pets. You can be sure that if someone's going to put red shoes on his pet's paws, as in this picture, that pet is ready for its close-up.

If you're photographing a pet on the street, you probably won't go up to it, stoop down, and snap your camera. If you do, you might get a snap from the animal! It's a good idea to ask the owner permission to photograph his pet. I've never had a pet owner say no when I've asked to photograph his pet. Also, if you take the time to position yourself to get the best possible angle of the animal, you'll find the owner may control the pet's behavior so you can get a good shot. Finally, don't go photographing stray dogs. In places such as Bolivia, abundant strays walk the streets, and some of them

Rabbits in cages on the back of a bike, caught at eye level.

are very handsome. Looks, in this case, are deceiving, as they can turn on a dime. I've been chased by squads of dogs by not thinking about the consequences first.

Just a little note about the settings: When I shoot candidly, I keep my aperture open wide in aperture priority mode. By keeping the aperture wide, I know my camera will choose the fastest shutter speed so that my subject stays sharp.

Last, a little about my all-purpose lens for candid photography. I use a 24-105mm f/4 lens, which gives me flexibility to zoom in on subjects a bit as well as to catch a scene with a wide angle.

Lens flare added with Photoshop.

Spicing Up Photos with Lens Flare, Noise, and Other Unusual Effects

The options for transforming your images using special effects with your camera and computer grow with each new model of camera and each new version of Photoshop and other image processing software. There are myriad ways to manipulate photos, but only a few that relate to the function of the camera and lens. By applying the same effects that are used in movies and film photography related to the camera and lens, you'll discover a time-tested realm of photographic art. This chapter defines those effects that are related to how a camera and lens function. Most of these effects can also be produced with image processing programs. How they are produced in these programs is also explained in this chapter.

ing High ISO Speeds to Add Noise

Supplemental Elements: ISO, noise, Photoshop, Photoshop Elements
Location of Picture: Theme Building, Los Angeles, California
Camera Settings: f/5, 1/10 sec, ISO 1600, 50mm

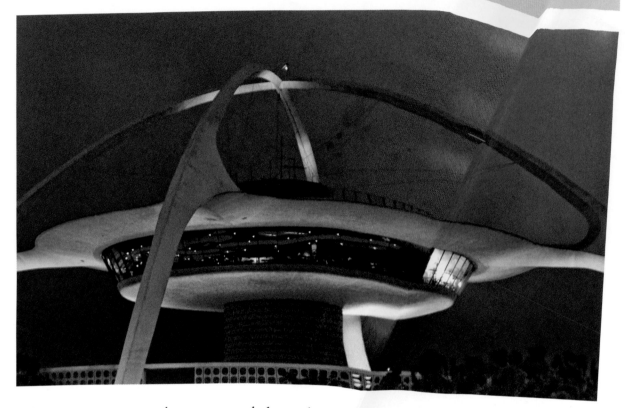

What more can you say about retro-cool than what's in the picture here? This is the Theme Building at LAX (Los Angeles International Airport). Architect Paul Williams designed it in 1961. Its spaceship look has the feel of *The Jetsons*, and get this—the top used to be a revolving restaurant. Oh, those were the days....

I've seen this as a nighttime image taken with a tripod so that it's sharp. The image is not nearly as impressive as when it's taken without a tripod at a high ISO speed. The noise (the tiny color-ful dots that you see throughout the frame) actually makes the spider-like building look even more like a spaceship landing on another planet.

Noise is easy to come by. You can make photographs noisier in many image processing programs, such as Photoshop and Photoshop Elements. All you have to do is go to Filter > Noise > Add Noise and then use the slider to adjust how much noise you want.

Overexposing Water Features in the Shade

Supplemental Elements: shutter speed, Rule of Thirds, long exposures
Location of Picture: Museo de Arte de Puerto Rico, San Juan, Puerto Rico
Camera Settings: f/22, 3.2 sec, ISO 200, 24mm

What's that? An exposure of more than three seconds during the day and no white out? How could this happen? It's really not all that difficult to understand. What you do is photograph in the shade with a very narrow aperture. Because the aperture is narrow, it takes longer for light to get through the lens, so the shutter can stay open longer. Overexposing requires that the shutter stay open longer still. In this shot I took in San Juan, the greens turn pastel with overexposure. The silvery water in the waterfall is the result of a long exposure. Notice, too, that I've placed the water feature in the left third of the frame, following the Rule of Thirds. The picture was taken at the Puerto Rico Museum of Art in San Juan, which has some very beautiful gardens that are perfect for photographing tropical vegetation.

Using Lens Flare for a Cinematic Look

Supplemental Elements: zoom lens, Photoshop
Location of Picture: LACMA (Los Angeles County Museum of Art),
Los Angeles, California
Camera Settings: f/4, 1/1600 sec, ISO 200, 46mm

You've probably seen it before in the movies. The camera moves toward the sun, and you see large circles moving through the frame. The circles, sometimes white and sometimes colorful, are lens flare. When you see an image that's crisp and clear, you don't think of it as being seen through a camera lens. But when you see lens flare in the frame, it reminds you that what you are seeing is through a lens. It adds a sense of realism to the shot.

A view through a lens is usually associated with motion pictures. The lens flare makes the frame look cinematic, adding drama to the image. The same is true for lens flare in a photograph. This shot shows an installation of street lamps at the Los Angeles County Museum of Art. While there is much drama in the repetition of the lamps, the lens flare that moves from the center of the frame downward gives the shot a cinematic look. The picture looks as if it could be a setting from a fantasy movie. To deliberately get lens flare in your frame, shoot with a zoom lens (there are more elements inside the lens that are likely to cause lens flare) into or just below the most extreme rays of the sun. If you don't want to go to the trouble of making lens flare out in the field, you can do it easily in Photoshop by using Filter > Render > Lens Flare and then tweaking the brightness with the slider.

Film grain added to photo using Photoshop.

Using an Ultra-Wide Angle to Create Distortion

Supplemental Elements: zoom lens
Location of Picture: Shanghai, China
Camera Settings: f/10, 1/4000 sec, ISO 800, 15mm

In this shot, the Oriental Pearl Tower (on the left side of frame) and surrounding buildings in Shanghai lean inward, a distortion caused by a fisheye lens. A fisheye lens has a focal length of 16mm or less (on a full-frame sensor).

An ultra-wide or fisheye lens can dramatically distort a photo so that the image looks as if it's being blown up into a big balloon. The effect varies according to where you place your subject and/or objects. In this image, the sky looks vast because it has been placed where there is maximum distortion in the frame.

Normally, you would try to avoid this distortion. It isn't always necessarily as pronounced as it is in the example given here. When it's more subtle, it can make landscapes look otherworldly. (See the "That End-of-the-Earth Feel" sidebar.)

THAT END-OF-THE-EARTH FEEL

Vast landscapes can take on an end-of-the-earth feel with a bit of barrel distortion. In this shot, the pavement in the foreground and the building in the middle of the frame protrude outward slightly toward the viewer. Because just less than half the frame is pavement, everything else in the frame is more pronounced, from the potted barrels with flowers in them to the people standing around.

Also making this shot compelling is that you really can't tell when it was taken because there are no cars or other objects that identify a time. I took this picture while on a trip across Montana on a Greyhound bus. The people are waiting around for the bus to move on to the next destination.

Slight barrel distortion gives this rural landscape an otherworldly feel.

Making People Look Like Ghosts

Supplemental Elements: shutter speed, tripod
Location of Picture: Palm Springs, California
Camera Settings: f/4, 25 sec, ISO 200, 24mm

It might seem like magic to get an image where someone looks like a ghost. The process of making an image like the one you see here is magical, but it's not magic. It's simply a self-portrait in near-dark conditions where the subject moves out of the frame while the shutter is open.

The first thing you do to take the picture is find a suitable spot to be the background of your shot. I chose a rocky background upon which a full moon was shining. The moonlight is perfect for this kind of shot because there's enough light for your camera to see what you're doing, but not enough to make your shutter open and close quickly.

To take this shot, you have to be in a place where you can leave the shutter open for at least 15 seconds. You need this amount of time because you're going to have to position yourself in the frame and then walk away. After you set your camera on a tripod, zoom in so there's enough room for a full-length portrait. Adjust the manual focus so your background is sharp. Then, set your camera to shutter priority mode with a shutter speed of about 25 seconds. Next, set the self-timer on your camera and press the shutter release all the way down. Quickly get into the frame and stay there for about 12 seconds. After that time has passed, slowly move out of the frame. Let the camera finish taking the picture. The final result will be a ghostly self-portrait.

Handheld shot of blurred subject.

Creating Sepia Tones

Supplemental Elements: black-and-white photography, sepia tones, autofocus point, depth of field, circle of confusion
Location of Picture: Tokyo, Japan
Camera Settings: f/6.3, 1/800 sec, ISO 800, 400mm

This dragonfly happened to be sitting on a book with Japanese text inscribed on it. I couldn't have asked this Japanese symbol of strength, courage, and contentment to have landed in a better place. I had a telephoto lens with me, and I stepped back from the insect and zoomed in. I set the autofocus point on the dragonfly's eyes so that the small depth of field around that point would keep the body sharp. Also sharp are the letters around the dragonfly.

In the picture you can see the circle of confusion, or the area in which the image just begins to loose sharpness. I produced the sepia tone of the image in post-processing. (See the "Grayscale and Split Tones" sidebar.) A sepia-tone monochrome photograph with a reddish tint makes the picture look old, giving it a kind of antique feeling.

GRAYSCALE AND SPLIT TONES

Photographs with reddish-brown sepia tones warm the soul, a kind of time capsule back to yesteryear. You can create sepia tones easily in Photoshop. But before you can apply a sepia tone, you have to convert the photo to black and white. When your photo is in Raw format, you can select the HSL/Grayscale tab and check Convert to Grayscale, then tweak the sliders. In the main program, you can convert quickly to black and white by using Image > Adjustments > Desaturate. Or, to have more control over the grays, you can select Image > Adjustments > Black-and-White and tweak the sliders in the dialog box.

For that perfect sepia tone, you can select the Split Tone tab in Photoshop's Camera Raw window and tweak the sliders. In the main program, select Image > Adjustments > Variations and select the tonal variations you want.

You have to convert to black and white before adding a sepia tone.

Putting a Stocking around a Lens to Soften Portraits

Supplemental Elements: photo filters, Photoshop, PhotoKit
Location of Picture: Los Angeles, California
Camera Settings: f/22, .6 sec, ISO 200, 35mm

If you don't have a diffusion filter or a program that does a decent job of emulating a diffusion filter (see the "Are Photo Filters Passé?" sidebar), you can put a stocking over your lens. Use normal, everyday women's hosiery available at your local drugstore. In this shot, I had a woman hold a wooden figurine as she posed for a photo. My lens was wrapped with a stocking. To do this, I first cut the stocking a bit bigger than my lens. Then I used a rubber band to affix the piece of stocking to the lens. In this shot I used aperture priority mode with a narrow aperture. Please note that the stocking will make your shutter speed slower because it cuts out some of the light reaching your lens. For this reason, you need to use a tripod for your shot.

ARE PHOTO FILTERS PASSÉ?

You might think that the filters you put on cameras are passé. Why go to the extra trouble and expense of using a filter when you can get a similar effect—not with Photoshop (it doesn't do pictures justice when you use their filters), but with PhotoKit, a program that works with Photoshop (not Photoshop Elements) and is available from Pixel Genius? Its website calls it "a photographer's plug-in toolkit comprising 141 effects that offer accurate digital replications of analog photographic effects." For more information about this program, you can go to www.pixelgenius.com.

Ruins at Bagan, Myanmar, taken with yellow filter attached to lens.

Myanmar landscape.

CHAPTER 11
Composing with Landscapes

There's no question about it—photographs of landscapes sell. But commercial value isn't the only reason to photograph landscapes. Their compelling peacefulness and beauty make them pleasurable to look at. An added advantage of landscape photography comes to photographers; they get to be outdoors, involved in an activity that is both relaxing and enjoyable. Whether you're going for silky-smooth flowing water or a stellar depth of field, you have to know the nuts and bolts of the camera settings and accessories you'll need to get that *wow* factor going on in your photographs. Photographer Ansel Adams provided us with some great techniques to get an excellent landscape photograph. From scouting out a location before you shoot to dividing your frame into zones, it is his photography that we strive to emulate.

sing Tight Apertures for Stunning Landscapes

Supplemental Elements: aperture, depth of field, tripod
Location of Picture: Yosemite Valley, California
Camera Settings: f/22, 1 sec, ISO 200, 24mm

This Yosemite Valley shot hit me while I was browsing through Bridge, Adobe Photoshop's photo management program. It came to me all at once why, out of nearly a hundred landscapes, I picked this one for this book. The photo represented autumn in Yosemite Valley in all of its glory—the dim light; the yellowing leaves on the trees that, from a distance, look like yellow springtime flowers; and the rocks, so many in so many different shapes and sizes. Last is the lack of much water in the streambed. I took this photo just prior to the beginning of the winter rains, so the bed was dry from months of no rainfall, with only puddles of water remaining from what once was a roaring stream and what will be a roaring stream once again.

When you're photographing landscapes such as this one or ones that are vaster—overlooks that span for miles and miles—using a tight, or narrow, aperture brings nearly everything from the

foreground to the background into sharp focus. The clarity of the shot comes from the use of a tripod, an absolute must for this type of photography. Actually, there's no way you could get this clear of a shot without a tripod—that is, unless you set your camera on one of the rocks. When you use tight apertures in aperture priority mode, the camera's shutter will need to open up longer for a proper exposure. (Remember, not as much light gets through a narrow hole as gets through a wider one, so the shutter needs to stay open longer to compensate for proper exposure.)

ADAMS' ZONES: THEY'VE COME A LONG WAY, BABY

Because I'm a fan of Ansel Adams, the photographer whose Western American landscapes have become world renowned, I know that a landscape has to be dramatic. Part of Adams' focus was the time of year he took his photographs. If he photographed a sky, it had to be breathtaking, with puffs of fog and/or clouds throughout the frame—hanging off cliffs, shooting into the stratosphere, or settling upon a lake, usually in winter after storms passed.

To be sure, Adams used a variety of complex techniques to light and frame his images. He developed a Zone System with fellow photographer Fred Archer, where he controlled every level from light to dark in a photograph through both exposure and the paper he printed on. The system was used for black-and-white photography and basically divided the shades from black to white using grays for the shades in between. Each shade changed according to how much the aperture was open.

The same basic system is used in evaluative or matrix metering on dSLR cameras. Setting your camera to evaluative or matrix mode will adjust

Lookout near the Coachella Valley in Southern California during the fall.

the highlights and shadows in your frame for the best contrast between light and dark because it measures the light from different points throughout the frame. The image in this sidebar shows a desert landscape with subtle shadows and highlights due to both the late time of day the photograph was taken and the setting of the camera to evaluative metering.

Using the Rule of Thirds for Landscapes

Supplemental Elements: aperture, depth of field, focal length
Location of Picture: Inle Lake, Myanmar
Camera Settings: f/8, 1/1000 sec, ISO 400, 70mm

If you're not sure how much sky to include in your photo, you can follow the Rule of Thirds. The rule states that the sky should take up approximately the top third of the frame. This shot of Inle Lake in Myanmar shows a landscape where the sky, clouds and all, takes up about the top third of the frame.

The rule also states that you should place subjects/objects about a third from the left or right of the frame. I could have followed the rule and placed the man one-third from the right side of the frame, but I did not. I broke the Rule of Thirds. I did so because I wanted the viewer's eyes to go right to the man to notice his unique stature at the end of the boat. Once the viewer's eyes get to that point they'll stay there, trying to figure out how the man balances himself at the front of his boat. Eventually, they'll figure out that it's the pole in the water upon which the man is balancing that helps him to stand. The lake is shallow, and the pole is secured in the earth below the water.

Breaking the Rule of Thirds—sky is a little less than one-third of the frame.

Adding a Vertical Object to Flat Landscapes

Supplemental Elements: light, shutter priority mode, aperture priority mode, Rule of Thirds
Location of Picture: Meteor City, near Winslow, Arizona
Camera Settings: f/7.1, 1/640 sec, ISO 400, 40mm

The sun's golden rays are being cast onto the billboard in this shot near Winslow, Arizona. I was able to catch the colors of a late-in-the-day sun by keeping my shutter speed short. The billboard advertises a trading post called Meteor City in Arizona. First and most important after I found the vertical object on the flatland landscape was to shoot it so it's about one-third from the left side of the frame (following the Rule of Thirds).

Vertical objects on flat land can range from a lone log cabin to a simple street sign. When you frame shots with a vertical object included, keep other extraneous objects out of the picture. Architect and commercial designer Mies van der Rohe once said "less is more," and that certainly can be applied to landscape photography.

To get this handheld shot, I set my camera to aperture priority mode at an aperture that was neither wide nor narrow, setting my focus point on the sign. I didn't use a narrow aperture because that would have blurred some of the scene. I didn't use a wide aperture because that would have made the camera keep the shutter open long enough that there would have been a risk of blur from camera shake.

SHOOTING AT DAWN OR DUSK

I don't know of any photography book that doesn't advise its readers to shoot at dawn or dusk. What they don't tell you is that dawn and dusk can last for up to two hours, with the light changing with each passing minute. First, there's the period of time when the sun above the horizon casts long shadows that often look surreal. Next, there's the light that the clouds diffuse, causing ribbons of color throughout the sky. Last is the midnight blue that peaks about an hour after sunset or an hour before sunrise and looks as if it's been painted up above.

To be sure, you should always scope out a landscape before you shoot it to check out where the best framing is and to find the time when the light is best, but that's not the only way to get a stunning landscape. Landscapes are ubiquitous and can be framed on the spot. They'll be breathtaking if the sky cooperates and easy to photograph when it's still light out.

It's always a good idea to have your camera with you, just in case you want to take a landscape shot

Some of the best photo ops during the day are when the sun can't be seen.

when the sky turns to those cosmic oranges and blues, as shown in this picture of palm trees against a striking sky. If you are out and about and you find the sky doing wonderful things, you can frame a shot from just about anywhere to meld the surrounding environment with the luminous sky. One way to catch the color is to shoot in shutter priority mode, setting your shutter speed to 1/500 second. If you find that the image is too dark after you shoot at that shutter speed, make it slower by setting it to 1/400 second and continue making it slower until you get the color you like. You can also lower the exposure compensation by a stop or two to enhance the orange and blue color. In this shot I used a 1/320 shutter speed with the exposure compensation set at −.33. The camera used f/4 for the aperture.

Making Flowing Water Look Like Angel Hair

Supplemental Elements: shutter priority mode, tripod, exposure compensation
Location of Picture: Yosemite Valley, California
Camera Settings: f/22, 1 sec, ISO 200, 55mm

The first thing you want to do to get water to look like the angel hair you put on a Christmas tree is lower your exposure compensation to its minimum EV value (usually –2). This will give you an opportunity to set your shutter speed longer because your camera will see the scene much darker than it really is. Then, you want to find a spot of moving water in a shady area. If it's in a sunny spot, there's a very good chance that you'll overexpose your photo when you go to shoot at a long shutter speed, even if your EV values are low. Next, you set up your tripod to photograph the part of the stream you want. If it's too rocky to set up your tripod, try setting your camera on a rock.

Begin shooting in shutter priority mode at a shutter speed of 1/8 second and work your way to longer shutter speeds, viewing your picture each time. Keep shooting, increasing the shutter speed by a stop each time until you get the shot overexposed. One of the shots you took before the shot that's overexposed is sure to be a good one. When you get home, you can pick the best exposure from the batch.

If you look at this shot from Yosemite Valley, you'll see that I framed it with a bit of the shoreline to give viewers a frame of reference so they can clearly see that the image is of moving water. If you zoom in too close to the water and rocks, there's a chance your viewers won't recognize the shot as moving water in a stream.

Finally, be careful! Don't put your tripod in a place where it might be shaky. Put your camera on a rock if you can't get your tripod stable. Also, keep the strap of the camera around your neck so the camera doesn't fall into the water.

A part of Yosemite Falls at slow shutter speed.

Excluding Gray/White Sky from a Landscape

Supplemental Elements: composition, color
Location of Picture: Tokyo, Japan
Camera Settings: f/6.3, 1/1600 sec, ISO 800, 40mm

Sometimes skies are so beautiful that you'll want the frame to be filled with the mixture of blues and whites that the sky contains. Other times they can be flat gray, nearly white, or even brown. In this shot taken in Tokyo, you can see the reflection of the sky in the water. (Notice the building in the reflection.) The water has no shades of blue because the sky reflected by it was white. White skies or mucky gray or brown skies, whether due to hazy or overcast conditions, make a photograph unappealing. You also get a white sky in the frame when you include the part of the sky near the sun.

But just because the skies aren't cooperating doesn't mean that you can't shoot. You always have the option of framing a landscape without the sky. This works well if what's on the ground is compelling, like the neatly cut pine trees and lake in this shot, which was taken on a day when the haze made the sky a flat light gray. While the sky was not compelling, the light that came from it to the ground was. The pollution dispersed it (the particles made the light go in different directions), making it less harsh than it would have been had the sky been pollution free. Since the light was less harsh and diffused, the shadows—small ones from each blade of grass to large ones from the trees—were lighter, which left all of the green in the frame even greener.

View of South Palm Springs without sky.

Using a Polarizing Filter to Get Rid of Glare

Supplemental Elements: composition, color
Location of Picture: near Livingston, Montana
Camera Settings: f/10, 1/200 sec, ISO 200, 35mm

No photography portfolio would be complete without a photograph of Montana's sky. Montana's nickname is "big sky country," and once you get there, you understand why. One of the reasons it can look so big is because there's open country just about everywhere—and usually with a sky filled with light peeking though clouds in every direction, like you see in this shot taken near Livingston. Using a polarizing filter (see "The Wonders of a Polarizing Filter" sidebar) enables you to cut out the glare and haze from the scene. Usually polarizing filters work best when the sun is off to your side, but sometimes when it is behind a cloud you can get good results by shooting into it.

THE WONDERS OF A POLARIZING FILTER

What can you put on your camera that gives you instant Photoshop-like control of a landscape scene? With the turn of a circular polarizing filter while it's attached to your lens, you can reduce reflection, increase contrast, and control color saturation. (There are linear polarizers, too, but they aren't recommended for auto-focus cameras and don't offer the control that circular polarizers do.) When you attach a circular polarizing filter to your lens, you simply look through the viewfinder while you rotate the filter to see instant changes in the scene. When you rotate the filter, waves of different wavelengths and frequencies of light are let through the filter to the lens with each orientation you choose. This happens because the Through The Lens (TTL) metering of dSLR cameras reads light that passes through the polarizing filter and lens. These images taken near Palm Springs, California, show a picture of an oasis when the polarizing filter was rotated so that the sky became lighter and then, with another turn, became darker. The latter has more contrast in tones so that the photo looks crisper—not to mention a sky that is a much deeper blue.

Polarizing filter rotated to give a lighter-colored sky.

Polarizing filter rotated to give a deeper-colored sky.

Many buildings are designed with symmetry in mind.

CHAPTER 12
Shaping Up with Symmetry

Symmetry, both manmade and that found in nature, intrigues. It offers us balance and beauty. It can also be haunting. Symmetry is defined as corresponding forms that match on each side of a dividing line. From architecture to the human form, symmetry is everywhere. Look no further than the Greek ruins, and you'll find that they were obsessed with symmetry. Go on a walk in the natural world, and you'll find an abundance of it. In photography, you can frame a shot of a symmetrical object anywhere in your photo, from the foreground to the background. You can also position many symmetrical objects into a group randomly or so that they appear symmetrical as a group in the frame. While objects may be symmetrical in real life, in a photograph they can appear as if they aren't. It just depends on the angle from which you take your photo. If you shoot an object that is symmetrical head-on from the side, the object in your photo will not appear symmetrical. That's the joy of creating a photograph—you decide its geometrical configuration.

Finding Symmetrical Human Figures

Supplemental Elements: f-stop, ISO speed, aperture priority mode
Location of Picture: Angkor Wat, Cambodia
Camera Settings: scanned from film

When you can align one half of an image with the other half so that if you were to fold it and each side would match the other, then the image is symmetrical. Most living things can be photographed so they are symmetrical within the frame. The human face and body are symmetrical. The figure in this shot was sculpted into one of the temple walls at the ruins of Angkor Wat in Cambodia. The head and body are symmetrical, as is the jewelry around the subject's neck.

Taking a picture of someone else's art requires that I give credit where credit is due. The temple was built during the reign of Suryavarman II by the Angkorian god kings. The entire complex of Angkor Wat was built with both symmetry and spirituality in mind.

Taking a photograph of someone else's art isn't the most challenging photo you can take, but it does require some knowledge of settings. To get a clear shot, you have to shoot at an ISO of about 800 because this and many other sculptures are in poorly lit places. If possible, shoot with a tripod, and if you don't have one, brace your body against a wall and keep your arms close to your body when you shoot. Shoot in aperture priority mode with an aperture of about f/8 so the entire figure stays sharp.

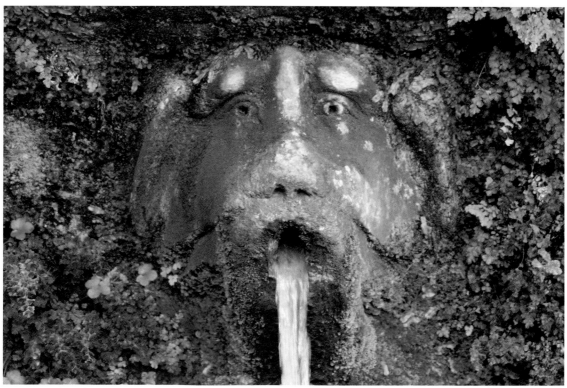

Statue at Villa d'Este, Tivoli Gardens (Italy).

Using Bodies of Water to Create Reflective Symmetry

Supplemental Elements: shutter priority mode
Location of Picture: Napo Wildlife Lodge, Ecuador
Camera Settings: f/4, 1/200 sec, ISO 500, 40mm

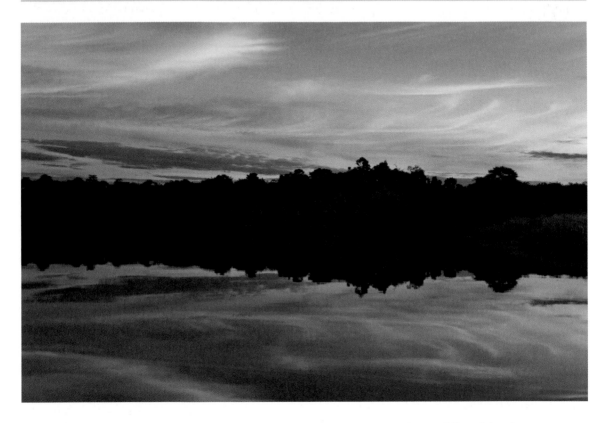

Imagine sitting on a wooden plank in a canoe on glassy water in the middle of the Amazon. That was the scenario I found myself in when taking this shot in Ecuador. This is one of those types of shots where you want to avoid softness in the landscape by shooting with wide apertures and fast shutter speeds. I shot this in shutter priority mode beginning with a shutter speed of 1/500 second. I then worked my way down to slower shutter speeds until I got the color both in the sky and in the reflection on the water. If I shot in aperture priority mode, the camera would not have underexposed the photo enough to get vivid colors. For example, the camera would only give me one shutter speed for f/4 for proper exposure, and that would make the shot overexposed. In shutter priority mode, I can get faster shutter speeds for f/4 to underexpose. To be sure, the camera will present a blinking aperture value to show that the exposure isn't right, but it doesn't know I want to underexpose. To see the symmetry in the frame, turn your head counterclockwise 90 degrees.

PHOTOGRAPHING SYMMETRICAL OBJECTS

There are many objects that we really don't think about as being symmetrical. That's because symmetry in photography only happens when you photograph a face of an object that's symmetrical. This shot shows the front of a car that is for the most part symmetrical, even with its hood up. It's difficult to classify manufactured objects as symmetrical because some are made that way and some are not. Here's a list of objects that can be symmetrical:

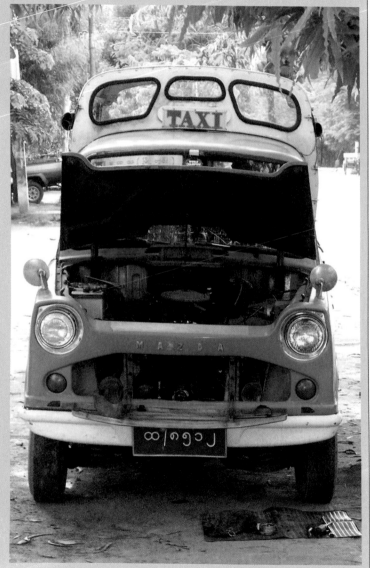

* Architecture

* Furniture

* Ships and boats

* Cars and trucks

* Trains

* Subway cars

* Toys

* Telephones

* Television sets

* Trailers

Usually the older an object, the more interesting photograph it will make. (See Chapter 15, "Back to the Future.") Remember, though, that in order for an object to be symmetrical in a photograph, it has to be photographed from certain angles.

Photographed straight on, the front and back of a car are symmetrical.

Looking for Symmetrical Façades of Buildings

Supplemental Elements: optical illusions
Location of Picture: St. Petersburg, Russia
Camera Settings: f/13, 1/200 sec, ISO 400, 58mm

From small town to big city, go anywhere in the world, and you'll find symmetry in the architecture. Some of it is so mesmerizing in photographs that it looks as if an optical illusion was planned in the design. In actuality, sometimes it is. (See the "Optical Illusions and Symmetry" sidebar.) Other symmetry is somewhat mundane, offering nothing more than two windows and a door.

This image shows a building in St. Petersburg, Russia, a city founded by Peter the Great. The architecture, including the symmetry of the building, is similar to that found in Europe because Peter the Great wanted St. Petersburg to look like a European city. Not only is the building's façade symmetrical, but so is the bridge that crosses the canal in front of it. Although St. Petersburg is not as well manicured as Europe is in many places, the scrappiness of it all (notice the chimneys and antennas that come up from the building behind it) adds a certain charm to the photograph.

OPTICAL ILLUSIONS AND SYMMETRY

Symmetrical architecture can be full of surprises. If you look at the white arrows in the façade of the building in this shot long enough, you'll probably have difficulty figuring out what direction they are pointing. The blue background makes it confusing. Another thing to notice is that the whole façade looks like an arrow pointing skyward. These are some ways architects keep you admiring their creations. When you take photographs of buildings like these, you'll have your viewers spending a little more time looking at them. The Greeks first used optical illusions as part of architecture. The practice has spread throughout many architectural styles, and it's present even in the modern skyscrapers you see today.

Stare at the shutters, and they'll appear to change in shape, color, and form.

Framing Tunnels or Bridges from the Center of the Structure

Supplemental Elements: perspective, depth of field, tripod, asymmetry
Location of Picture: Yosemite National Park, California
Camera Settings: f/22, 20 sec, ISO 200, 24mm

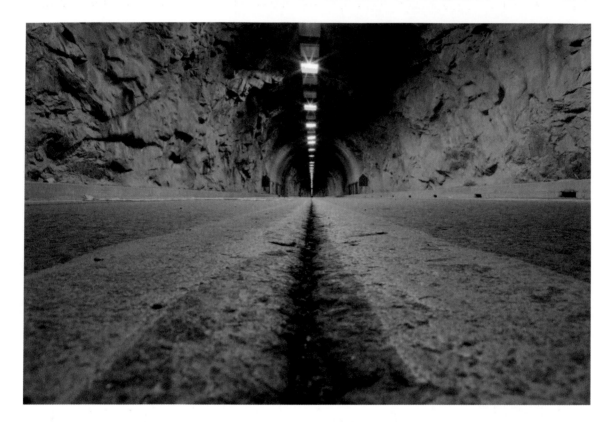

When bridges, tunnels, or railroad tracks are photographed straight on, most of the time they turn out symmetrical when laid out in a two-dimensional photograph. They probably also have a perspective point in the middle of the frame, not to mention a good deal of depth.

The real challenge in these types of photographs is being able to get the shot. Usually there is a lot of traffic traveling on bridges and in tunnels (but not railroad tracks), so if you try to shoot from there, you might get run over. One alternative is to shoot from inside the car on a bridge while you are traveling closest to the middle lane. If you can shoot from close to the center, you'll get a nearly symmetrical shot. Sometimes you'll miss, and your bridge will turn out asymmetrical (see the "Asymmetry in Action" sidebar), which isn't always a bad thing. In fact, many photographers recommend asymmetry in shots.

In this picture I was able to shoot from the middle of the road by setting my camera on the road. There was no traffic anywhere in sight, so I was able to take a couple of shots from this perspective. I used a narrow aperture (large depth of field) so that the entire frame is sharp. The narrow aperture also created a small star effect on the lights at the top of the tunnel. The shot has a bit of symbolism in both its yellow cast and its foreboding lines. It's kind of eerie and seemingly dangerous because you get the feeling that a vehicle will come at any moment. The color of the photo comes from the lighting in the tunnel, which is reflected off of the road and rock walls.

ASYMMETRY IN ACTION

When you photograph bridges and tunnels off center, you'll get an asymmetrical image—that is, you couldn't align one half of the image with the other half if you were to fold it. The first image here shows a picture of a bridge in Shanghai that is asymmetrical. The picture was taken from the inside of a taxi. If you were to try to fold it vertically from the middle, almost everything would line up, except the cables, which is what makes it asymmetrical. The tunnel shot shows that when the tunnel is photographed from a sidewalk, the perspective point shifts off center, but all the lines in the frame still meet it.

The most interesting thing about the difference between these two images is that the viewer's eyes end up shifting to see the perspective point in the tunnel shot, whereas there are no shifts in eye movement when the bridge is photographed straight on. That's because the bridge is nearly symmetrical, and the shot of the tunnel from the sidewalk is not.

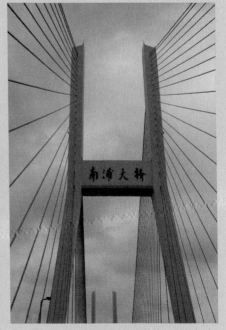

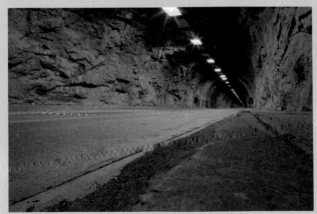

The tunnel is asymmetrical.

The bridge looks symmetrical, but it isn't.

Photographing Colored Glass Patterns

Supplemental Elements: ISO speed, aperture priority mode
Location of Picture: Notre Dame Cathedral, Paris, France
Camera Settings: f/5, 1/200 sec, ISO 1600, 350mm

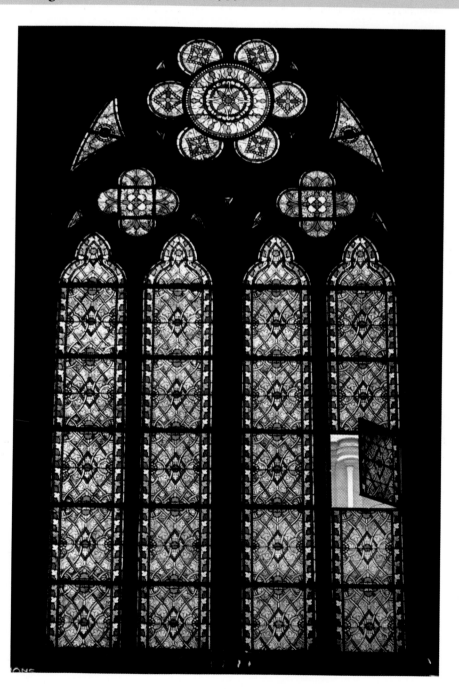

This stained-glass window in Notre Dame in Paris shows symmetry in all its beauty. One window is open, which throws off the symmetry a bit, but I included the picture in this section because the principle subject in the photo is one of the most beautiful manmade works of symmetry there is.

Aside from symmetry, the first thing you want to think about when photographing inside a church is whether you can use a tripod. Although some churches will let you photograph inside with a tripod, some won't. Grace Cathedral in San Francisco will let you photograph inside with your tripod, and Notre Dame Cathedral in Paris won't.

You can probably guess the reason why churches have a no-tripod policy. Many are just too crowded to accommodate them. Notre Dame is filled with tourists throughout much of the year, which would make it very difficult to set up a tripod.

The other alternative for taking a sharp photo of a symmetrical stained-glass church window when you can't use a tripod is to increase your ISO speed. (For more information about ISO speed, see the "Photographing in Museums and Palaces" sidebar in Chapter 1.) When you use a high ISO speed, there's always the risk of getting noise in your photo, but with today's cameras you can get a reasonably sharp image in a poorly lit place by using a high ISO speed and a wide aperture when shooting in aperture priority mode. The image of the window shows just how good a photograph can come out by using a high ISO speed in a poorly lit place.

BACKLIT SIGNS: A BREEZE TO PHOTOGRAPH

There's one more reason why you can get sharp pictures of stained-glass windows: They are backlit. You can get some terrific exposures without a tripod when photographing a bright backlit sign or a stained-glass window because of the evenness of the light that makes it to your sensor.

This shot shows a backlit sign I photographed in Shanghai, China. Workmen were standing in front of it, and I took a quick shot at an ISO of 400—a shot that came out relatively sharp. When a stained-glass window or backlit sign is very bright, you not only don't have to use a tripod, but you also don't have to increase your ISO speed that much (ISO 400 usually will do).

When shooting in aperture priority mode at a wide aperture, your camera will calculate efficiently a fairly fast shutter speed—one that's fast enough not to get blur from camera shake. From experience, I've found that some camera models do better at producing a sharp, noiseless picture at high ISO speeds than others. The cameras that do better aren't even necessarily the most expensive ones.

Backlit signs photograph nicely without using a tripod.

Handheld shot taken in Russian museum at 800 ISO.

Technical Tango

The terms *f-stop*, *ISO speed*, and *depth of field* challenge many people. For some, the terms are intimidating enough to keep them away from a dSLR camera. In reality, though, these concepts are fairly simple. The f-stop refers to the size of the opening in a lens through which light enters and reaches the sensor when the shutter is open. ISO speed is how sensitive the sensor is to light. If it's more sensitive (a high ISO speed), your camera will be able to take sharper images in darker places. And the depth of field is just how much of your frame is in focus. There you have it. We've done the technical tango. Come on in, and let's dance some more as we fool with these and other camera settings.

Using a Tripod to Photograph Blinking Signs

Supplemental Elements: black-and-white photography, sepia tones, autofocus point, depth of field, circle of confusion
Location of Picture: Las Vegas, Nevada
Camera Settings: f/8, 1/13 sec, ISO 400, 50mm

There's no question in my mind about the wonders of high ISO speeds. Many times they photograph signs at night just fine. (See sidebar Photographing Neon at Night in Chapter 15, "Back to the Future.") However, when there's not much light emitted from the sign and/or parts of it have dark areas around them, a tripod is essential. I tried photographing this sign without one, and I got camera shake. I thought I could get away with shooting at a shutter speed of 1/13 second without a tripod, but I couldn't. With the tripod, the photo is sharp and can be blown up to a large size with no problem. (See the "Topnotch Equipment Needed for Big Blowups" sidebar.)

The motel sign in this shot is beautiful, but the neighborhood is, in a word, lousy. Shady night-time activities occur in the downtown neighborhood where I shot the sign, and it isn't the best idea to go up to this sign and others like it with an expensive camera and tripod. While all of this is an accurate story, I went ahead and did it anyway only because this sign is one of the best designed mid-century modern artifacts that line Las Vegas Boulevard—or anywhere else in the city, for that matter.

TOPNOTCH EQUIPMENT NEEDED FOR BIG BLOWUPS

If you're looking to make one of your photographs mammoth-sized, you'll need a mighty sharp photo for it to look good big. Here are some ways to get your photo the sharpest it can be:

* **Use a dSLR camera.** Although many point-and-shoots have mighty megapixels, their sensors are tiny, and a photo taken with one will degrade if it's blown up any bigger than 8×10.

* **Use low ISO speeds.** If you shoot with an ISO speed higher than 400, there's a good chance that you'll get noise (tiny colorful dots all over your print) if you blow it up big.

* **Use a good tripod.** If you're shooting in anything less than bright sunlight, you'll need a tripod; otherwise, you risk blur from camera shake. When you buy a tripod, remember that you get what you pay for. Don't scrimp on this important piece of equipment. Many cheap tripods won't hold the bigger dSLR cameras securely.

* **Watch your aperture.** If you shoot with a wide aperture, know that you'll get softness in some of your frame if you're shooting subjects/objects at close distances.

If you want to blow up a photo to a very large size, you should shoot with a dSLR camera.

Using Different Autofocus Points in Two Shots of the Same Scene

Supplemental Elements: autofocus point, blogging
Location of Picture: Los Angeles, California
Camera Settings: f/4, 1/8000 sec, ISO 200, 105mm

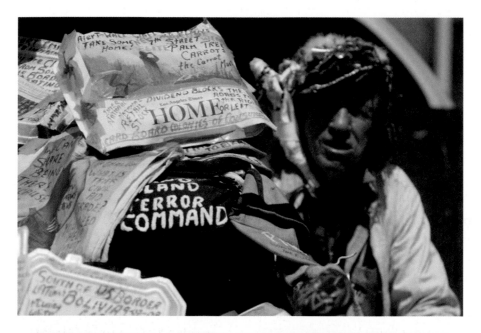

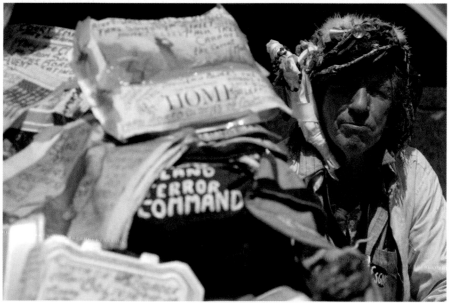

Where you place an autofocus point can change your entire shot. I photographed a homeless person with an unusual display of items covered with text of all different sizes and fonts sitting next to him on a shopping cart. I took two shots of this scene—one setting the autofocus points on the items and the other with the autofocus point set on the man.

You can probably guess how this changes the perspective on the shot. But there's more here than meets the eye. When the man is sharp, he is more prominent; your eye heads right to him so that you are not focused on the blurred text next to him. Just the opposite is true when the man is blurred and the text is sharp. The words "terror," "command," and "HOME" take over the shot—their implications left to you, the viewer of the photos.

ARE YOU A DOCUMENTARY PHOTOGRAPHER?

On my blog (digitalartphotographyfordummies.blogspot.com), I once posted a shot of some pine trees in Yosemite Valley, California. I wrote the following post:

Pine trees in California have been weakened by drought and disease.

I can remember a couple of decades ago when pine trees in California were robust and healthy—thick, plentiful branches soaring to the sky. The branches still soar to the sky, but now many of these trees are stricken by disease. They aren't the best subjects for photographers anymore.

The most common disease to strike pines is the Armillaria Root Disease. Its effects are devastating trees all over the U.S.

Next is the canker (sounds horrible, doesn't it?). It discolors trees. You'll see resin seeping out from various places on the trunk of the tree. Once the trunk of the tree is affected, it's pretty much over for that tree.

To get pictures of healthy trees, you have to go up to British Columbia, a journey I want to make someday. If anyone has some photos of BC trees, please send us a link.

The very same day I received the following comment to the post:

That sort of really shines a light as to how important photography should be looked at from a strictly documentary standpoint. If certain trees end up dying off, only photos will remain. Of course, this isn't just about trees. This is about anything else that has the possibility of extinction or annihilation.

Need I say more about documentary photography? It's pretty much spelled out here. Remember that your photos are your documents, and if you photograph the right subjects and/or objects (things that will no longer be around), your photos will become more interesting as years and decades pass.

Changing Light in a Frame by Vignetting

Supplemental Elements: aperture, Photoshop
Location of Picture: Los Angeles, California
Camera Settings: f/4, 1/2000 sec, ISO 200, 24mm

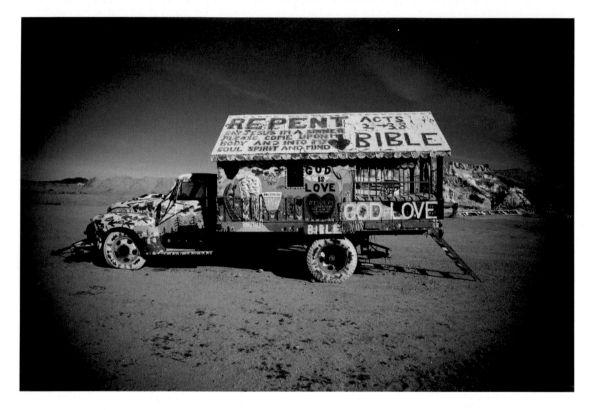

Scattered around Salvation Mountain near the Salton Sea in Southern California are painted vehicles with images and Bible passages written on them. I caught one of the vehicles by itself at a wide angle on a bright, sunny day using a wide aperture, circumstances that are ripe for getting vignetting. Vignetting (see the "Moving Light" sidebar) is an effect in which the corners of the frame are darkened. There are several causes for vignetting. One is mechanical, such as a filter or lens hood obstruction that gets worse at wide apertures. There is optical vignetting, which is caused by light hitting the lens aperture at a strong angle, especially with wide angle lenses used at wide apertures. Pixel vignetting is caused by light that hits the sensor at an angle. In this shot there is severe vingnetting, which causes a black circle not only in the corners, but all the way around the frame. In this case the image looks as if it is being seen through a telescope. I achieved this effect by using Photoshop to enhance vignetting that was already in the frame. Photoshop and other image processing programs can also eliminate vignetting, which is what you want to do most of the time.

MOVING LIGHT

When you get vignetting in some pictures, you won't want to remove it. Because the corners are darker than the center of the frame when there is vignetting, a subject in the center of that frame will appear well lit against those dark corners. In other words, vignetting seemingly appears to move light to the center of a frame. In this image, the lighting enhances the action of the man (dumping water onto the street). If there were no vignetting, light would be uniform around the frame and not nearly as interesting.

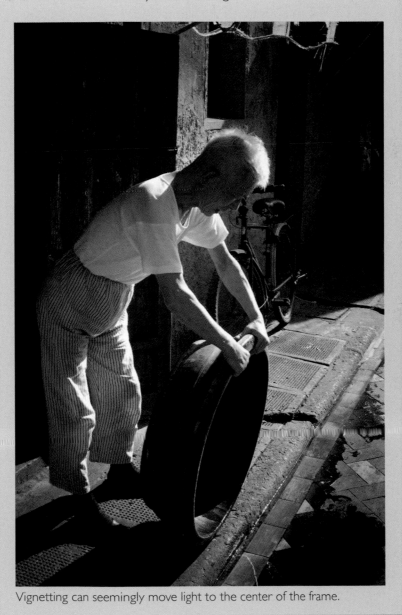

Vignetting can seemingly move light to the center of the frame.

Using High ISO Speeds to Photograph in Low-Lit Places

Supplemental Elements: ISO speed
Location of Picture: Mandalay, Myanmar
Camera Settings: f/5.6, 1/125 sec, ISO 1600, 110mm

Capturing the Mandalay Marionettes puppets with my sensor brings to life an age-old tradition of the Myanmar puppetry. The puppets originally educated people about culture, history, and religion. This tradition slowly disappeared, as did the puppets. In 1986, they were brought back to life by a group of artists who wanted to restore the folk-art tradition.

Photographing a puppet show in a small theater requires that you sit in the front row, which is what I did to get the image here. The Mandalay Marionettes Theater is dark, no question about it. The only light that shines is on the stage where the puppets perform. By setting my camera to a very high ISO speed, I was able to get a sharp picture because it allowed me to achieve a higher shutter speed (than if the ISO speed were lower) at a reasonable f-stop.

Before I set out to photograph the puppets, I set my camera to burst mode so that I could take a quick succession of pictures in an effort to get one of them sharp.

Keeping Apertures Open Wide in the Shade

Supplemental Elements: ISO speed, aperture priority mode, shutter speed
Location of Picture: Just west of Palm Springs, California
Camera Settings: f/4, 1/80 sec, ISO 200, 70mm

Just west of Palm Springs was a pig in the shade under some bushes at a rest stop. Not a pig at the trough, not a pig with lipstick on its lips—just a plain old pig covered with a blanket for slumber.

I wanted a good shot of this animal, and I knew from previous experience that it's easy to get blurred shots when taken in the shade. To photograph this pig, I set my aperture to f/4 in aperture priority mode, the widest it would go. With the aperture wide open, the shutter speed was a bit shorter than it would have been if I had shot with a narrower aperture. In order to absolutely ensure a sharp shot, I could have raised my ISO speed, which would have made my shutter speed a bit faster. I took three shots—the first two of the pig's entire body and the last one a close-up of its head. I was happy when I got home and viewed the close-up shot of the pig at 100 percent on my monitor. I saw that the pig's head was incredibly sharp. This pig certainly is a fat, friendly photo op.

Using the Right Combination of Camera Settings for Sharp Photos Inside

Supplemental Elements: ISO speed, aperture, depth of field, focal length
Location of Picture: Los Angeles, California
Camera Settings: f/4, 1/50 sec, ISO 800, 28mm

In an effort to discover the optimum settings for an indoor shot without a tripod, I went down into the Los Angeles subway system. The settings I came up with are the result of some experimentation in an indoor environment. I used two types of dSLR cameras, each with a different-sized sensor and both set at the same settings. The resulting shot was the same for both cameras. They give you a sharp shot in moderate indoor lighting with little or no noise.

I've found that an ISO setting of 800 is great for the indoors. It's just high enough to get your shot considerably sharper, yet low enough to avoid noise. The next optimal setting for this kind of shot is using a wide aperture in aperture priority mode, which gave me a higher shutter speed to capture the

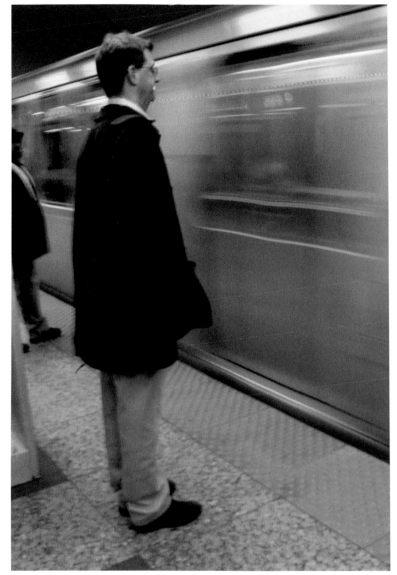

Sometimes blur is not such a bad thing!

subway station without camera shake. Further contributing to sharpness is using a relatively wide focal length. If you have a zoom lens, the more you zoom in (above 50mm), the less depth of field you will have, which means blur in part of your shot.

The last factor to consider in getting a sharp shot indoors is your camera-to-subject distance. If the subject is far away, as in the subway picture, you'll get a greater depth of field and an increased chance of a sharp shot; if it's closer, you'll get blur in your frame from a small depth of field.

A cat and dog in Paris.

CHAPTER 14
Daytime, Nighttime, Anytime

I don't know how many times I've been out at night humming the old Cat Stevens song "Moonshadow." When I do, you can bet on a couple of things—I'll be out when there's a full moon, and I'll have not only my camera, but my tripod, too. For landscapes, I'll have scoped out the place where I'm going to be photographing, both at night and during the day, to get an idea of the shapes and forms of my soon-to-be-shot image. I'll have found a place high up, where one looks below at sloping tree-filled canyons that lead to pearl necklaces of city lights. Whether it's the sun or the moon, day or night, photographing under special circumstances during these times takes a few extra measures than just shooting an ordinary snapshot.

Moonlight is just one part of the day when special care is needed for a shot. There are specialty photographs that you can take day or night from a plane, at an amusement park, or at sunrise or sunset that will spell W-O-W and that will have your viewers talking.

Creating a Moonscape in a Rocky Area Just After Dusk

Supplemental Elements: f-stop, continuous shooting mode, shutter priority mode, aperture priority mode
Location of Picture: San Francisco, California
Camera Settings: f/8, 8 sec, ISO 200, 105mm

If you can find a rocky ocean shore or lakeshore, you can convert it to what looks like an eerie moonscape. To do this, you'll need a camera that offers manual controls for shutter speed. (All dSLR cameras and some point-and-shoot models do.) You'll also need a tripod. Next, you'll need to find a location with rocks and moving water. You'll have to go there just before the sun lowers beneath the horizon, when you can set up your tripod and camera. You can start shooting when the last of the sun sinks below the horizon.

The first shots you'll take are scouting shots. You'll be aiming your lens in a couple of different directions to see what makes the best composition. You'll also be testing different shutter speeds to see which ones get you the best exposure. Start with a shutter speed of half a second and, as it gets darker, increase the shutter speed to get the waves looking like fog. To do this, shoot in shutter priority mode (T or Tv mode; see Chapter 5 for more info about shutter priority mode).

In this San Francisco shot, there is no horizon in the frame. Omitting it is what makes the photograph look as if it was taken on a planet other than Earth. The long shutter speed that was used to take the picture made a floating fog-like surface just above the rocks, an effect that's easily achieved if there is moving water and waves pounding against the shore.

ABOVE MARRAKECH: HOW TO PHOTOGRAPH FROM A PLANE

The first thing you have to do in order to shoot a picture from a plane is to make sure you get a window seat. Make your reservation early, and if you book online, make sure you make your seat selection when prompted. If you buy your ticket on a site such as Priceline.com, you'll have to call the airline after you've made your reservation to reserve a window seat.

Marrakech looks surreal as seen from a plane.

When I'm in the air, I usually take pictures both at takeoff and during landing. There has been only one time out of dozens when a flight attendant has asked me to put away my camera, but there's always that slight risk. I set my camera to continuous shooting mode (sometimes called *burst mode*) so I can get one picture after another, so as to have a large selection of pictures from which to choose.

Most of the time, the closer you are to the ground, the better the picture will come out. This shot shows the view of Marrakech just before landing. If you shoot in aperture priority mode and set your aperture wide, your shutter speed will be fast enough to freeze the action on the ground. You can use your autofocus point to keep the camera focused on one place while the plane is moving. To do this you'll have to move your camera so it stays on that point while the plane is moving. Some of the shots from the series you take will come out blurred, while others will be relatively clear. It just depends how much you've shaken the camera and how much you've veered from the focus point that you have set. Finally, your shutter speed should be at most 1/500 second to reduce the chance of blur from the motion of the plane. One warning: Don't press your lens against the plane window, or you may get vibration caused by the plane's engines.

Getting Sunrise and Sunset Golden

Supplemental Elements: f-stop, continuous shooting mode, shutter priority mode, aperture priority mode
Location of Picture: San Francisco, California
Camera Settings: f/6.3, 1/100 sec, ISO 400, 16mm

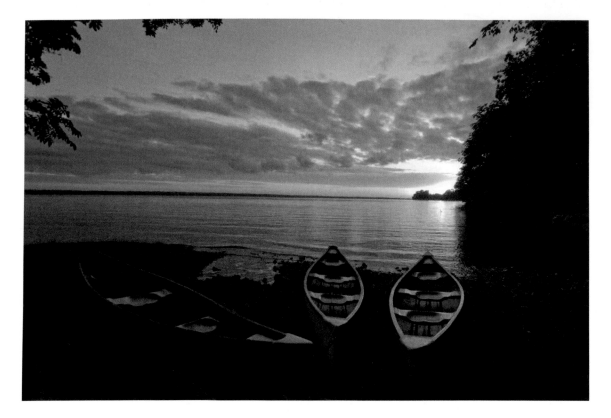

The first thing to do when photographing a sunrise or sunset is to plan where and when you are going to shoot. Scope out a location where you know there's an interesting foreground—for example, the boats in this San Francisco shot.

The next thing you want to do is check the weather. Look for forecasts with scattered or partly cloudy skies. This is optimal for getting sunsets or sunrises where the light bounces off of the clouds for a really spectacular show. If it's cloudy or raining, skip the sunset or sunrise picture and wait for another day. If it's hazy or clear, you might have the opportunity to get the sun as a giant orange ball.

Once the sun is near the horizon, it will go down quickly (or come up quickly if it's sunrise), so you have to work fast. There are three ways to get good color in your sunrise and/or sunset

shots when the sun still provides lots of light in the sky. The first is to shoot in shutter priority mode and start with shutter speeds of about 1/400 second, working your way to slower shutter speeds as the sun moves down toward the horizon. Use a tripod if you're shooting at shutter speeds slower than 1/100 second. You'll find that at some of these shutter speeds, the f-stop value will blink. This is the camera letting you know that you won't get optimal exposure in that shot. What you are doing, then, is overriding the corresponding shutter speed and f-stop value because you want your photo underexposed to bring out the color. The second way is to shoot in aperture priority mode with your exposure compensation set down a few stops and the aperture set to a middle setting (f/6-8), where it's open neither wide nor narrow. In setting your exposure compensation at, say, −1.5, you'll get an underexposed shot, which will bring out move vivid colors of the sunset. The third way is to shoot in aperture priority mode with no exposure compensation changes and lock the exposure (see the "Using the Exposure Lock to Underexpose or Overexpose Your Shot" sidebar) on a lighter part of the sky and then reframe your shot to get your image underexposed.

Once the sun has gone well below the horizon, getting a good shot is less likely because it will be too dark for proper exposures. Even if you try long shutter speeds, if it's fairly dark outside, your camera will see that and soften any surfaces among which it can't distinguish well.

USING THE EXPOSURE LOCK TO UNDEREXPOSE OR OVEREXPOSE YOUR SHOT

When your camera is set to center-weighted average light metering (see the "Metering Methods Defined" sidebar in Chapter 4), you can use the exposure lock feature of your camera. If you want to add more light to your frame (overexpose), press the shutter release halfway down while pointing your camera's autofocus point at a darker nearby surface. After you hear a beep (some cameras beep, but others don't), keep the shutter release button down while you reframe your shot, and when you find the right composition, press the shutter

Lock the exposure on the water, then reframe picture to lighten scene.

release all the way down. If you want to take away light from your frame (underexpose), repeat the aforementioned procedure except point your camera at a lighter surface. Please note that with some cameras, pressing the shutter button halfway locks both exposure and focus. So, you may encounter some focus problems depending upon where you point your camera and how much depth of field you have. In this shot, I lightened the scene by locking the exposure on the water (setting the focus point there and pressing the shutter release halfway down) and then reframing the shot and pressing the shutter release all the way down to get the composition you see in the picture.

Making the Sky Iridescent Blue

Supplemental Elements: exposure compensation, manual mode, tripod
Location of Picture: Palm Springs, California
Camera Settings: f/22, 2 sec, ISO 200, 35mm

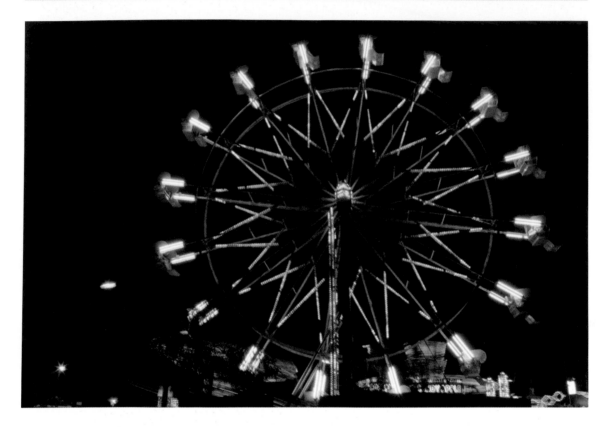

There's a certain time of day after the sun sets and before the sky turns black that something rather surreal occurs—the sky turns an iridescent blue. You can't use autofocus to shoot the sky when it's this color without something bright on the ground on which to focus. In this shot, the sky was caught in all its radiance with a sharp focus on the lit amusement-park ride.

To get this shot, you need a tripod and patience. You'll need to set your shutter speed at about a half second and your f-stop to 22 (to get streetlights to turn into stars, see "Stars in the Streetlights—Manual Mode") in manual mode (the mode where you set both shutter speed and aperture) for the first shot and then increase the time the shutter is open with each additional shot as the sky gets darker. You'll find that your first shots will be overexposed, but as the night wears on, you'll get to a window of time when the sky turns to the beautiful iridescent blue that you want. Take a few more shots after that, just in case the sky gets to an even better color.

STARS IN THE STREETLIGHTS—MANUAL MODE

Narrow apertures can turn lamplights, into brilliant stars. Check out the lamps at the bottom of the frame. The light disseminates in all directions. Setting your camera to a narrow aperture has the same effect on a ball of light as squinting your eyes does. Try squinting while looking at a lamp and you'll see a star-shaped light. When you open your eyes all the way, it turns back into a ball of light. If you don't like the star effect caused by narrow apertures (like squinting eyes), then you can widen your aperture so the effect will lessen (like keeping your eyes open wide).

You can get this effect in any mode, but it's easiest when you use manual mode. In this mode you select both aperture and shutter speed. (See your camera's manual for the correct way to change shutter speed and aperture in this mode.) To get the iridescent blue, set your f-stop to 22 and your shutter speed to about half a second. Check your image, and once the sky starts turning a medium blue, take some more shots, gradually increasing your shutter speed. You'll have to watch your exposure meter on the bottom of your LCD (exposure compensation reading) to get the correct exposure. When the line blinks, you can adjust either the shutter speed or the aperture up or down.

You can change the aperture to a reading other than f/22, but you'll lose the star-like quality that the streetlights get at a narrow aperture if you make it wider. When you get the correct exposure, the line will stop blinking and will be near 0. You have to be very patient because there will be only a short window of time when the exposure is right at f/22 so that both the streetlights and the sky are the way you want them.

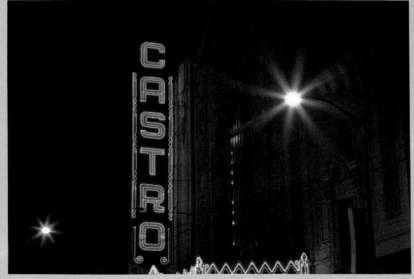

You can get both stars from the streetlamps and an iridescent blue sky when you work in manual mode.

Photographing an Amusement-Park Ride Moving at Night

Supplemental Elements: shutter speed, aperture priority mode, self-timer, light
Location of Picture: Paris, France
Camera Settings: f/22, 1.6 sec, ISO 100, 20mm

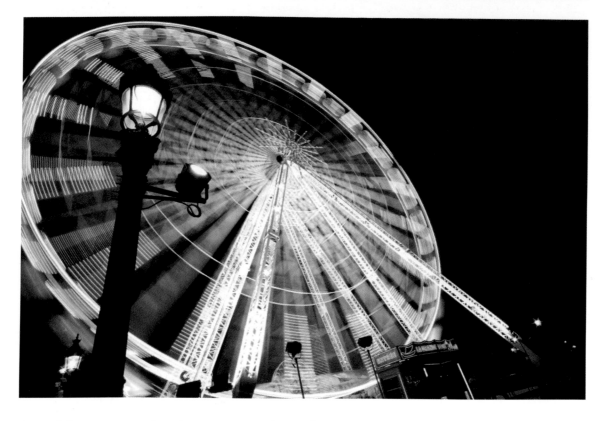

One of the most stunning shots you can take is of an amusement-park ride while it's moving. The lights swirl into beautiful repeating patterns in a photographic show that's sure to win over lots of viewers. Any amusement-park ride is game for making what looks like photographic fantasy come to life with your lens. Novices will say that taking a shot like the one shown here is complex, but it really isn't all that hard. All that's required is a tripod and a dSLR camera or a point-and-shoot that's capable of taking pictures with long shutter speeds.

When you're at the park, position yourself in front of the ride with the ticket booth or some other object that won't move during the shot. (When you have a sharp object in your frame, it shows the viewer that any motion blur is caused by motion and not camera shake.) Set your camera to aperture priority mode, then set your self-timer so that your camera won't take the

shot until a few seconds after you've pressed the shutter release button. Then wait for the ride to start moving. Press the shutter release button all the way down, and you'll hear beeps. Some cameras flash a light on the front of the camera to count down to exposure. Wait for the beeps/flashing to end and then listen to your camera as the shutter clicks open. Wait several seconds until you hear the shutter close. Quickly review your image and then reposition your tripod for another shot. It's always good to take a series of shots so you can choose the best one when you look at the full-size images on your computer screen when you get home.

PARK RIDES WHIRLING

When photographing amusement-park rides, you have many apertures from which to choose in aperture priority mode. The ride pictured here made uneven elliptical orbits in three dimensions. In the photograph the three dimensions have been reduced to two, thus the revolutions of the ride turn into various elliptical orbits in the photographic frame. When working in aperture priority mode, the narrower the aperture you set your camera to, the longer the shutter speed will be, which will add extra revolutions to the ride that result in extra ellipses of light in your frame, which is what makes the image really cool.

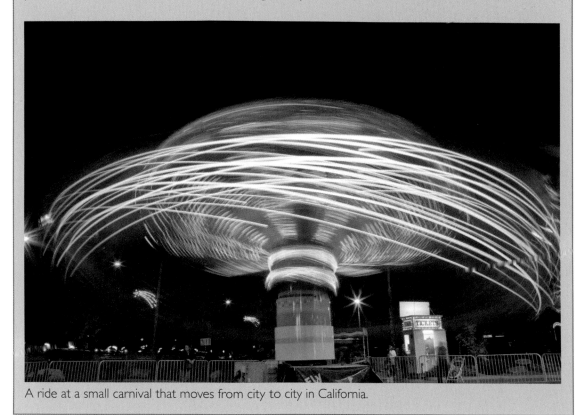

A ride at a small carnival that moves from city to city in California.

Photographing a Full Moon at Dusk

Supplemental Elements: shutter speed, spot metering
Location of Picture: Palm Springs, California
Camera Settings: f/5, .6 sec, ISO 200, 105mm

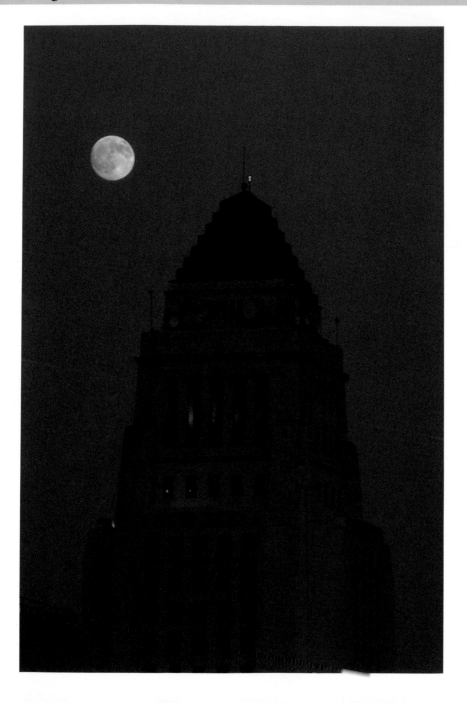

Shooting when there is a full moon at dusk requires a tripod. The only time you can shoot the moon without a tripod is when it's out in the daytime. (See "The Daytime Moon in a Snap" sidebar.) This image I took in Palm Springs shows a full moon shot in shutter priority mode. There was enough ambient light in the scene to pick up the building without it being a silhouette. The moon appears sharp, with good coloration, just as you'd see it while gazing into the sky.

I used spot metering so that the light recorded in the scene was read only from just around the autofocus point when it was placed on the moon. I then reframed the shot to include the top of the building with the moon casting its light over the building from above. I lowered my exposure compensation as low as it would go (–2) to bring out the details of the moon. The building appears a bit dark because the light for the shot was metered from a bright spot (the moon).

There's only a narrow time gap when you can photograph the moon with a long shutter speed. If it's too dark, the moon will appear pure white with light cast in all directions from it.

THE DAYTIME MOON IN A SNAP

If you see the moon up in the sky during the day, and you happen to be in a beautiful setting or you can frame it with some nearby trees, you won't need a tripod. You can shoot it just as you would any other landscape. If you want more detail of the moon, you can set your autofocus point there, then reframe your shot. Your shot will come out a bit darker, but it will be well worth it when you see the detail of the moon. (See the "Using the Exposure Lock to Underexpose or Overexpose Your Shot" sidebar earlier in this chapter.)

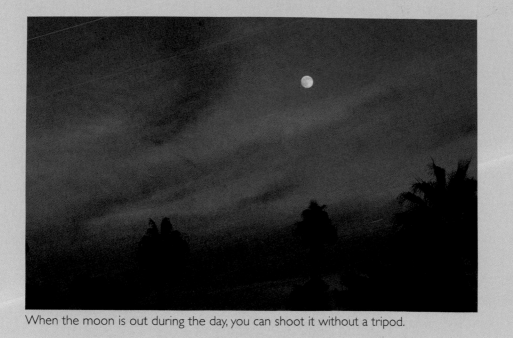

When the moon is out during the day, you can shoot it without a tripod.

Using the Moonlight to Illuminate Landscapes

Supplemental Elements: manual focus, self-timer, tripod
Location of Picture: Palm Springs, California
Camera Settings: f/4, 20 sec, ISO 200, 24mm

Photographing by only the light of the moon is really no different than photographing just after dusk, when the sky turns midnight blue as the waning sun's light diminishes. There's only a narrow time period after dusk when you can get a midnight-blue sky because it quickly turns black when the sun's light has passed. That's not the case when the moon is full or nearly full. You get an entire night (as long as the moon is shining) to photograph a landscape and get that midnight blue–colored sky, like that shown in this Palm Springs shot.

This type of shot is a bit more of a challenge than other types of shots because you can't always use autofocus points. While the moon does provide light—and mysterious, compelling light at that—it's not enough to be picked up by the autofocus point. Therefore, you have to use manual focus. (See the "Manual Focus Quick and Easy" sidebar.)

There are also weather restrictions to consider. Moonlit landscape shots are best when there's no wind. Since you're looking at exposures as long as 30 seconds, trees will move considerably during that time if it is windy. This will cause them to blur, and your shot won't be as effective. Don't let all of this keep you back, though, because once you are out in the natural world when a full moon is beaming down over the landscape, adrenalin will rush through your body because of the beauty of it all.

When you're setting up (of course, you'll need a tripod), look where the moon is casting its light. If the moon is in the eastern sky, shoot toward the west. You need not include the moon in your shot. One advantage of shooting a moonlit sky is that it will turn blue with long exposures, and the stars will become glimmering white dots in your frame. Use your self-timer when you shoot so you don't shake the camera as you are pressing the shutter release button. Finally, make sure your moon shadow stays clear of your lens.

MANUAL FOCUS QUICK AND EASY

Manual focus comes in handy when your camera is having difficulty autofocusing. You may know the drill. You try to autofocus in the dark (or near dark), and the camera's mechanism goes to all the possible focusing options and can't find one. In this moonlit landscape shot, I couldn't get my camera to autofocus, so I used manual focus with amazing results. All you have to do to control the manual focus after you change the setting (usually a switch on the barrel of the lens) is turn the focus ring near the end of the lens barrel. To focus, find any light source (a lamp, for example) you can and turn the lens ring until it's sharp. Manual focus is good to use for macro photography or any other type of photography where you want to be as precise as possible with what's sharp in the image.

A moonlit landscape shot in manual focus.

Using Your Flash to Photograph a Night-Blooming Flower

Supplemental Element: flash
Location of Picture: Palm Springs, California
Camera Settings: f/5, 1/2000 sec, ISO 200, 105mm

Ordinarily, the light from a pop-up flash is extremely harsh—so much so that you'll want to make sure it's turned off for most shots. There are many kinds of flash systems that you can use for effective flash photography, and they are discussed in the "All About Flash" sidebar. However, pop-up flash units on dSLR cameras can make for some great special effects, such as photographing flowers at night.

This shot shows that the harsh light picks up vibrant colors and turns them surreal, as if they could be made from wax or cake frosting. Having beautiful flowers to work with also helps. I grow my own roses—a job that's not hard in many climates. All you have to do is plant the bush and fertilize it after it takes root, and you'll have picture-perfect roses to photograph within several weeks.

ALL ABOUT FLASH

Flashes that come with point-and-shoot cameras and pop-up flashes that come with some dSLR cameras usually put out too much light in a limited space, giving your pictures a white cast with a black background. They also are positioned in such a way that the light goes directly to the eyes of subjects you are photographing, causing red eye. There's nothing worse than having your subject's eye bright red in a photograph you've taken of him. Red-eye, an effect that makes subjects' eyes turn red in a photo, happens when the flash on a camera fires and light travels directly into the eye and bounces off the retina, back into the camera lens. There are two ways to lessen the red-eye effect—move the flash so it's not aimed directly at the eyes or emit light before the flash so that pupils get small enough so that light can't bounce off of them.

Flower girl in Myanmar, taken with flash.

To get a better range and eliminate red eye effectively, you might opt for an external flash unit. Many can be mounted on a "hot shoe" or connecting device on the top of dSLR cameras. Many flash units for dSLR cameras can automatically adjust the camera white balance settings and the zoom flash position to match the sensor size of the camera to which the unit is attached. These auto adjustments are important for getting the color cast right in your photo and for preventing blown highlights and large dark areas in your photograph. It's also true that flash units can electronically recognize your camera's exposure, focusing, and zoom settings when the camera is set in P mode and the flash unit is attached. The only drawback to P mode is that the background of your shot will be dark. The optimal setting for using flash to pick up both the subject and some of the background is to put your camera in manual mode, set with an f-stop of about f/5.6 and a shutter speed of about 1/60 second.

DSLR cameras have a hot shoe to which you can attach a flash unit. The external flash units have more power than the pop-up flashes that come some dSLR cameras. Their flash range, or how far they emit light, is much farther. Since the flash unit is mounted a good distance above the top of the camera, it's further away from the eye so that you can prevent red eye.

When buying a flash unit, you want one that puts out light that extends beyond your subject so you can see the background. Flash units come with a maximum guide number, which measures the maximum distance the light will go to illuminate the subject. The higher the guide number, the farther the light from the flash will go. Finally, it's not a good idea to use an older flash unit—such as one that went on your old film camera—on a digital camera, because it could burn out the camera.

'50s vintage black-and-white TV set.

Back to the Future

Those were the days, my friends—days when cars had chrome, signs had neon, and telephones had rotary dials. Yesterday's technology is today's retro keepsake. I've always said, for example, that you can buy and keep an old typewriter for your shelf that is sure to collect dust, or you can just take a picture of it, frame it, and put it on your wall—a better keepsake that takes up less space and doesn't collect dirt and grime. There aren't many people who won't turn their heads when they see a vintage auto cruising on the highway, and there won't be many people who don't turn their heads when they see a picture of one in your home. Photography is one of the few mediums where you can put your viewers in a time machine, taking them back to the time period of your favorite part of history.

Taking Close-Ups of Vintage Vehicles

Supplemental Elements: aperture, color, text, candid photography
Location of Picture: Idyllwild, California
Camera Settings: f/4, 1/200 sec, ISO 200, 67mm

A wide aperture, almost-perfect light, great color, and old-fashioned text provide this candid shot of a vintage truck with photographic details that keep viewers' eyes on the interesting subject. When I saw this lighting from the front view of the truck—indirect, even light that comes from outside the shaded area—I knew that was the position from which I wanted to take the shot. I stooped down near the front of the truck, turned my camera around to get a vertical shot, and framed it without the headlights. I felt the headlights would take away from this shot's sharp focus on the chrome bumper and text and the red hood and roof.

The only quibble a professional might have with this photo is the classic bad bokeh (small circles that become lighter around the edges) in the background. However, because this car is solid red, the background bokeh provides good contrast with the roof of the truck's cab. Furthermore, the muted bokeh created in the transparent rear windows is in good contrast with the background. Each adds to the perspective and depth of the photo.

ASKING PERMISSION TO PHOTOGRAPH IN AN ANTIQUE STORE

It's not only antique stores that have the excellent photo opportunities. Consider antique shows and my favorite—modernism shows. The first thing that might cause concern when considering an antique photo op would be the proprietor of the store (or space, if it's a show) not wanting his items photographed. No worries there, as I've never been refused when I have asked permission to photograph in such places.

Antique radio at the Palm Springs Modernism show.

I took this photograph of an antique radio at the Palm Springs Modernism show. This was one of about a dozen radios that all had similar designs. The radio's owner loved the fact that I was photographing his radios.

The next thing you might wonder is why you would want a photograph of an antique when you can buy it. My answer for this has been that you can't hang an antique on a wall (unless it's a clock or a plate), but you can hang a photograph of one on the wall.

There's an added plus to making photographic art out of old antiques. A picture of a typewriter or radio in a frame collects much less dust than the real thing, and the picture, believe it or not, looks just as good, if not better. I've had people buy my photographs of old typewriters and radios, and they just love them.

Finally, the only thing you need to remember to do when photographing these things is to set your camera to a high ISO speed. Personally, I don't like to use flash because it creates too much harsh light. Photos of antiques seem to take to ambient light just fine. For a list of upcoming antique/modernism shows in the U.S., go to www.dolphinfairs.com.

Finding Ghost Signs on Brick Buildings

Supplemental Elements: aperture, repeating objects, color, exposure compensation
Location of Picture: Socorro, New Mexico
Camera Settings: f/14, 1/500 sec, ISO 200, 60mm

My guess is that you won't see many big advertisements for cigars in this day and age. Today, the pastime of cigar smoking has been taken up by an esoteric few. Way back when—some 50 to 100 years ago—cigars were the Western masses' idea of a good time. They could be had for five cents. This shot from New Mexico shows the efforts people took to make good use of the sides of brick buildings by slapping on layers of paint specially made for brick.

In the American West, these signs are everywhere, from the mid-sized cities to the small towns. Left to the elements, the paint wears down so that the brick shows through, giving an interesting effect.

When framing a sign like this, you have to decide whether you want part of the building with the sign or you want to just tightly frame the sign with the least amount of obstructions. I framed this one to exclude a horrible black shadow cast from the building next door over the edge of the right frame.

Some ghost signs look like new. That's because they are. People have taken to refurbishing them, which means you can't really call them ghost signs anymore. (More about that in the "Ghost Signs" sidebar.)

When photographing these signs, you want the sharpest picture possible—that is, you want to be able to see the detail of each brick, and yes, you want to capture any details of a sign underneath the sign. If at all possible, photograph the sign with the sun shining on it. If it is, you're sure to get a sharp image because shutter speeds will automatically be fast, especially if you choose wide apertures (in aperture priority mode). For sharp photos of signs that are in the shade or in a dark alley, make sure you shoot with the widest aperture possible. If you do, there's a much better chance you'll get a sharp photo without blur from camera shake. Remember that your camera will set a slower shutter speed if there isn't much light.

GHOST SIGNS

Back in the late 19th and early 20th centuries, brick (brownstone) buildings were painted with advertisements for a variety of products. By the late 20th century, some of the signs remained and became known as *ghost signs*. They contain faded and peeling paint, often revealing a *pentimento* effect—one image showing through another.

This image shows a ghost sign originally painted in the 1930s in Butte, Montana. In Butte there are more than 30 of these signs still visible from the streets of the city.

Ghost sign in Butte, Montana, originally painted in the 1930s.

Photographing Neon Signs during the Day

Supplemental Elements: color
Location of Picture: Blythe, California
Camera Settings: f/6.3, 1/1000 sec, ISO 100, 75mm

It's common knowledge that neon looks great at night (see the "Photographing Neon at Night" sidebar), but did you know that it can look just as good, if not better, during the day? Usually the signs are painted bright colors, and when that paint hits the sun, they become masterpieces like this one in Blythe, California. There's no question that the colors are faded by the sun, but that leaves them for you to photograph as a variety of new colors that look like they've just been invented.

When it comes to photographing signs, look for the side of the sign upon which the sun is shining. If you take a picture of a neon sign on a cloudy day or if the sign is shaded, the results aren't nearly as good. To get a shot with the sun shining on the sign, you have to photograph it either in mid-morning or mid-afternoon. Set your exposure compensation down a stop or two to really saturate the colors. (See "Creating Blasting Colors from Murals and Graffiti" in Chapter 7.)

PHOTOGRAPHING NEON AT NIGHT

It's no secret that Las Vegas is the neon capitol of the world. Colors blast and blink up and down the strip. A little-known secret is that some of the best neon is downtown. Shooting neon's a breeze because it emits more than enough light for your camera's sensor to pick up a clear picture of it without using your flash. By setting your ISO speed to 800, you'll avoid any blur from camera shake. Shoot in aperture priority mode with an aperture of 6.3. This shot shows Vegas Vickie, who resides in Fremont Center downtown. Don't miss the other neon signs at the center, either. They are part of the Las Vegas Neon Museum's outdoor galleries, which are open 24/7.

Vegas Vickie sits on top of the Glitter Gulch at Fremont Center in downtown Las Vegas.

Capturing the Grandeur of an Old Movie Palace

Supplemental Elements: scanning film, film photography, architectural style
Location of Picture: Los Angeles, California
Camera Settings: f/8, 1/500 sec, ISO 200, 75mm film

Just as neon is great to photograph during the day, so is the movie palace marquee. This photograph might surprise viewers because many people don't know that Los Angeles has a grand movie palace called "Los Angeles." This is one of many theaters downtown that were part of what was the Los Angeles theater district.

This picture was scanned from a film negative. A negative that is scanned into a computer using a consumer-quality flatbed scanner isn't nearly as high quality as a digital image; however, it does retain that film quality, the slight hint of film grain and colors that are vivid and more natural-looking than many images taken with a digital camera. With all that said and done, you're better off sending your negatives to a scanning service, because those businesses can afford the expensive equipment it takes to get a good-quality scan.

WHEN THEATERS THRILLED

Built in the classiest neighborhoods in cities from Honolulu to Stockholm and in the small towns across rural America, the grand movie house set the tone for an era of red-carpet film premieres all over the world. Spotting the marquee was just the beginning of an escape from the humdrum cycle of humanity.

The grand theaters can be seen around the landscape of the United States, Canada, and Western Europe as monuments to the grand, moving films that were shown inside. With names such as Paramount, Art, Vogue, Ellen, and Fox, these movie palaces were integrated into city and town landscapes as grand Art Deco monuments. After the middle of the century, new theaters took new forms, with many included as part of malls in the suburbs. Small towns were deserted as the industrial society wound down, and by the end of the century many theaters stood empty, their marquees in disrepair.

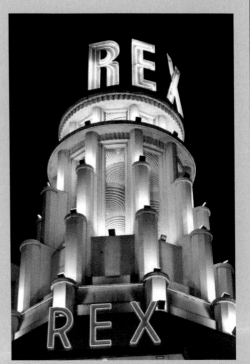

The Rex Theater in Paris.

By the 1990s the theaters experienced a revival in the big cities, with some turning to live theater palaces and others having their insides gutted and expanded so that they could obtain profitability by showing two or more movies inside. This shot shows the Rex Theater in Paris, an Art Deco–styled building that lights up the city at night.

Index